THE CONTEMPORARY OIL PAINTER'S HANDBOOK

THE
CONTEMPORARY
OIL PAINTER'S
HANDBOOK

A COMPLETE GUIDE TO OIL PAINTING:
MATERIALS, TOOLS, TECHNIQUES, AND AUXILIARY SERVICES
FOR THE BEGINNING AND PROFESSIONAL ARTIST

Clifford T. Chieffo

PRENTICE-HALL, Inc., *Englewood Cliffs, New Jersey*

Library of Congress Cataloging in Publication Data

CHIEFFO, CLIFFORD T
 The contemporary oil painter's handbook.

 Bibliography: p. 117
 Includes index.
 1. Painting—Technique. 2. Artists' materials.
I. Title.
ND1500.C574 751.4'5 75–40302
ISBN 0–13–170167–3

Printed in the United States of America

Prentice-Hall International, Inc., *London*
Prentice-Hall of Australia, Pty. Limited, *Sydney*
Prentice-Hall of Canada, Ltd., *Toronto*
Prentice-Hall of India Private Limited, *New Delhi*
Prentice-Hall of Japan, Inc., *Tokyo*
Prentice-Hall of Southeast Asia Pte. Ltd., *Singapore*

To PAT, to whom my life and this book are dedicated, and without whom there would be no life or book.

To NINA MARISA (scientist, doctor, artist, and ballet dancer—her order) and TOBY MARIA (vocation to be determined), our daughters, who are my very soul.

CONTENTS

Chapter Three

SIZES AND GROUNDS
23

Chapter Four

OIL PAINTS,
OILS, AND SOLVENTS
33

ix

References

PREFACE

The basic ideas put forth in this book stem from a critical need that I have been unable to fulfill in my sixteen years of teaching oil painting. It is well known that all students need demonstrations and lectures about the craft of oil painting, materials, tools, and techniques. In addition, when artists get past the student stage in their careers, they require more information on auxiliary matters, such as crating a painting for shipping, photographing, as well as conserving and caring for damaged oil paintings. These subjects have been largely overlooked in most artist's manuals.

Through the years, I have had to refer my students to ponderous texts, many of them considered "classics" in the field. To art students, the best of the texts were thought of as shelf books rather than as personal, concise reference tools. The challenge was to write a readable manual comprehensive enough to include all the salient information on oil painting, but sift through that information and make time-saving recommendations.

I want to stress that this book will not touch upon aesthetics or various painting styles, because I believe that it is nearly impossible to set aesthetic values that the majority of artist/teachers would agree upon. The book's purpose, then, is to supply the entire art community with the most compendious information on oil painting possible.

It should be emphasized that these methods and techniques are my personal recommendations based on my experience, and therefore may vary from other texts on the subject.

ACKNOWLEDGMENTS

I acknowledge a deep debt and extend my gratitude to the following people:

To Bill Setten, formerly with Prentice-Hall, who urged me to write this book.

To Walter R. Welch, Assistant Vice President, College Division, Prentice-Hall, whose patience, good humor and undying faith kept me going.

To Hilda Tauber, Emily Dobson, and Marvin Warshaw, of Prentice-Hall, whose editorial and design efforts converted my manuscript into this book.

To Anton Konrad, Analytical Laboratory, Smithsonian Institution, one of the country's finest conservators, who provided advice for the section on the conservation of paintings.

To Marion Mecklenburg, Washington Conservation Studio, an outstanding and knowledgeable conservator, who took time out of his busy schedule to advise and inform me on the conservation of paintings.

To Joshua C. Taylor, Director of the National Collection of Fine Arts, Smithsonian Institution, and especially the following members of his staff: Burgess Coleman, Joshua Ewing, Bob Johnston, Tom Bower, and Tom Carter.

To Maria Recio, Cassie Murray, Joyce Kaminski Guiliani, Lindsay Fontana, and especially my administrative aid, Leslie Thorp, who suffered through my illegible handwriting to type the rough drafts.

To Johnnie Parris, typist extraordinaire, whose good nature, late hours, and neat typing pulled the manuscript through.

To William Auth, super photographer, who developed and printed the photos in the lab, working at all hours.

To Chuck Myers, an extremely talented artist, for his outstanding line drawings.

To the companies that supplied photographs and information about their products, in particular: The Kodak Company, M. Grumbacher, Inc., Winsor & Newton, Inc., Masonite Corporation, James Howard Company, Permanent Pigments, and Weber Company.

To Pat and Howard DeVoe, Barbara Yoffee, Mike Baker, Ron Sachs, Fr. Eugene Tucker, S.J. (Loyola Retreat House), and Steve and Ellen Levine, who were helpful in many ways.

To my Mom and Dad and my wife Pat, *tanti baci.*

Chapter One

HISTORICAL DEVELOPMENT
OF OIL PAINTING

Chapter One

HISTORICAL DEVELOPMENT
OF OIL PAINTING

Oil painting, that is, the use of **linseed oil** as a vehicle in which to grind the dry **pigment**, instead of egg yolk (**tempera**) or wax (**encaustic**), was gradually developed during the fifteenth and sixteenth centuries. Investigators have traced this development from many different perspectives using many research tools, including the observation of aesthetic and stylistic changes, records of the day in the form of bills of lading, early manuscripts, personal records and accounts by artists as well as accounts of the lives of artists by writers of the day, and finally chemical and physical analysis of the paintings. As Sir C. L. Eastlake notes in *Methods and Materials of Painting of the Great Schools and Masters* (New York: Dover, 1960), vol. 1, pp. 19–20, Aetius,

a medical writer of the fifth and beginning of the sixth century [A.D.], at length mentions a **drying oil** in connexion with works of art. After speaking of the oleum cicinum, he proceeds to the description of linseed oil,—now first distinctly mentioned,—and observes that it is prepared in the same manner; that its (medicinal) uses are the same. . . . Almost immediately after this, he mentions walnut oil as follows:

"Walnut oil is prepared like that of almonds either by pounding or pressing the nuts, or by throwing them, after they have been bruised, into boiling water. The [medicinal] uses are the same: but it has a use besides these, being employed by gilders or encaustic painters; for it dries, and preserves gildings and encaustic paintings for a long time."

Thus the use of linseed oil in connection with the arts appears as early as the fifth and sixth centuries. The mention of **oil varnish** (**resin** dissolved in oil) appears in the eighth century, and by the twelfth century the use of drying oil as a **medium** for **paint** (used in decorative arts) is confirmed. Eastlake continues (vol. 1, p. 58):

In reviewing these various documents, and others of the kind, it will not be difficult to determine the modes in which oil was used among the materials for painting. First, it was employed in the composition of **varnishes**; probably also as a **mordant** for gilding. . . . Next, as at Ely and Westminister, and as the directions of Eraclius and others prove, it was used from first to last in painting walls, columns, stone, and wood. Lastly, the proofs of its having been employed for pictures, in the

modern sense of the term, are less distinct, and are not numerous.

Exactly when the use of drying oils in conjunction with decorative painting or the use of **oil glazes** over tempera became oil painting as we know it is a question still unresolved. But certainly the development of oil painting is linked as much to the development of aesthetic and manipulative skills as it is to the development of new materials. Other artists painting during the time of the Van Eyck brothers Jan (1380–1441) and Hubert (1370–1426), the acknowledged first masters of oil techniques, may have used oil techniques as well, but perhaps because of aesthetic considerations their work is not noted by history. And so the search for the exact date of oil paint's first use and the *secret ingredient* of the Van Eycks, which *allowed* them to produce magnificent works of art, is somewhat misplaced and misleading. As Eastlake concludes his discussion of late fourteenth century oil painting (p. 88):

Thus it appears that, about the year 1400, the practice of oil painting, however needlessly troublesome, had been confirmed by the habit of at least two centuries. Its inconveniences were such that tempera was not unreasonably preferred to it for works that required careful design, precision and completeness. Hence, the Van Eycks and the painters of their school seem to have made it their first object to overcome the stigma that attached to oil painting, as a process fit only for ordinary purposes and mechanical decorations. With an ambition partly explained by the previous unavoidably coarse applications of the method, they sought to raise the wonder of the beholder by surpassing the finish of tempera with the very material that had long been considered intractable. Mere finish was, however, the least of the excellencies of these reformers.

Faber Birren, in his *History of Color in Painting* (New York: Van Nostrand Reinhold, 1965) traces the development of the use of oil in underpainting as well as in glazes in Italy. According to Birren, Antonello de Messina (1430–1479), who spent many years in Flanders, brought the technique to Italy, where it was slowly perfected by artists like Leonardo da Vinci (1452–1519), who used oil for underpainting. The use of oil continued to develop throughout the Western world, and at the end of the sixteenth century and during the seventeenth century it became the universal medium. Evidence of the popularity of oil painting during the mid–seventeenth century is cited by R. D. Harley in her book *Artists' Pigments, c. 1600–1835* (New York: American Elsevier, 1970), p. 7; referring to Henry Peacham's book *The Compleat Gentlemen* (1634), she notes that it "appears to be the first book in English to discuss portrait painting in oils. . . . The author makes an interesting comparison of painting in oils and water colours, giving reasons why the latter is more suitable for the amateur." Harley then quotes Peacham:

Painting in Oyle· is done I confesse with greater iudgement, and is generally of more esteeme then working in water colours; but then it is more Mechanique and will robbe you of over much time from your more excellent studies, it being sometime a fort-night or a moneth ere you can finish an ordinary peece. . . . Beside, oyle nor oyle colours, if they drop upon apparrell, wil not out; when water-colours will with the least washing.

And so with Peacham's advice to the amateur, we can begin our contemporary look at the materials and procedures of oil painting — as we know it to be.

THE STRUCTURE
OF PAINTING SUPPORTS

Chapter Two

THE STRUCTURE OF PAINTING SUPPORTS

The terms **support, size**, and **ground** refer to the preparation of a surface (canvas, board, paper, etc.) for the application of paint. All surfaces must be prepared in some manner to prevent the pigment, oil, and solvents from deteriorating the support and/or to facilitate adhesion of the paint to the surface. All three phases of preparation are equal in importance.

Brief definitions of the terms *support, size,* and *ground* are as follows:

Support — any material or combination of materials (canvas, wood, paper, etc.) to which the paint is actually applied.

Size — any number of **aqueous** (waterbase) glues or preparations that are used to isolate the oil and **solvents** in the paint from the support.

Ground — an actual layer or film of paint which provides the proper surface for the application of the oil paint.

The details of the function and application of sizes and grounds will follow in Chapter 3. The present chapter discusses the various supports in common use.

A. CANVAS (TEXTILES, FABRIC)

The most common form of support for oil paintings is **canvas**, a term loosely applied to both **linen** and **cotton** fabric.

A.1 Linen

Linen, made from the fibers of the flax plant, has been through the centuries the preferred painting support because of its strength and stability. Also, it has a "give" or flex to its weave when it is fully stretched.

A.2 Cotton

Cotton, made from the seed hair of the cotton plant, is less expensive than linen and is in wide use today. It is particularly popular with artists who paint with acrylic-base paints on its unprepared surface. These artists usually desire the paint to stain and soak into the cotton canvas. Generally, this is a safe practice if the **acrylic** paints are of good quality. The stained effect is a purely aesthetic decision made by the artist. Oil paint can

be used successfully with this method of painting if the proper sizing is used, as described in Chapter 3.

Cotton is commonly used by students because it is readily available and inexpensive. It can be a good support for oil painting if it is properly prepared (see Chapter 3) with a glue size and a ground of white lead paint or with an acrylic preparation. The acrylic preparation combines the size and ground into one **solution**.

When buying cotton canvas be sure that the weave is tight, because a loose weave accents its inherent tendency to sag and stretch under humid conditions.

One way to judge the canvas's suitability for painting is by its weight. The weight of any canvas fabric is designated as the weight per square yard. The minimum weight for painting canvas should be 11 ounces. In canvas less than 11 ounces in weight the strands are too thin and the weave too open, thus making it an unsuitable support, even for student work. Cotton bedsheets and tailor's pressing cloth are much too flimsy to be considered as painting supports.

B. FACTORY-PREPARED READY-TO-USE CANVAS

Factory-prepared canvas, readily available at most art supply stores, is linen or cotton canvas that has been sized and coated with a white paint ground and is ready for use in painting. Buying prepared canvas saves time and energy, but it is very expensive.

When buying prepared canvas, one should look for the qualities of good fabric plus a well-prepared ground. Because it is already prepared, it may be more

difficult to judge the weight of the fabric, but a quick look at the weave and the size of the threads will give you some idea. Very thin threads in a loose weave, for example, indicate a minimum-weight canvas. Further observations can be made by holding up the prepared canvas to a strong light. A good tight weave and a good ground should block out most of the light. The ground can be easily tested for proper adhesion to the canvas by rolling a corner of the canvas over your index finger and observing whether this cracks or flakes off the fabric. A properly applied ground will withstand such a test with no problem.

Some further considerations regarding fabric supports are as follows:

1. Some canvas may be found that is made from a weave of both linen and cotton, as well as other fabric combinations. This combination is generally undesirable because of the tendency of the linen and cotton to react differently to humidity. Because each type of fiber expands and contracts at a different rate and under different conditions, the canvas can lose its even tension, causing folds and sags to appear in the stretched painting and perhaps causing the surface of the finished painting to crack.

2. Traditionally, other desirable characteristics of linen have been said to be its natural tan color and the distinctive characteristic look of its weave. Author-artists enamored of these characteristics have generally not recommended cotton simply because of its whitish color and different weave appearance. The special qualities of linen, in my judgment, have been overrated and are merely sub-

jective, aesthetic opinion. I feel that the artist should be aware of the physical and visual properties of both linen and cotton and then judge these properties in relation to the needs of his own work.

3. Burlap, made from jute, is frequently suggested by students for use in painting, but I have found it wholly unsuitable. The weave is too coarse, open, and brittle. The fiber is too weak and will not withstand the tension of stretching and painting. In addition, a proper application of a ground is almost impossible. Even when a ground can be applied, the small hairs of the fiber create a very abrasive surface on which to paint. Such a surface, even after a light sanding, can wear down a paint brush in a very short time, thus making the inexpensive burlap very uneconomical.

C. RIGID SUPPORTS

Rigid supports, usually wood, were in common use before the use of canvas and oil paint became popular. A rigid support was then necessary because the particular glue, pigment ground, and tempera paint film used was extremely inflexible. These early supports (panels) were generally made of solid oak, poplar, or mahogany. Although it is still possible to paint on such panels today, it is rarely done. The expense and detailed preparation necessary to ready them for painting is generally out of keeping with today's materials and images.

Firm or inflexible supports may still be preferred by some artists strictly on the basis of the "feel" of the support during painting. The following are the various hard supports in common use today.

C.1 Masonite ®

Masonite, a product of the Masonite Corporation, is a board created by compressing wood fibers under pressure. It is probably the most widely used hard support in this country because it is widely accessible and will not split, crack, or warp under normal conditions.

Tempered and untempered Masonite is manufactured in 4x8-foot sheets and in thickness ranging from 1/8 to 1/4 inch. It is best to use untempered, 1/4-inch-thick Masonite for oil painting because, first, untempered Masonite has no additives (vegetable-type tempering oils) in its structure that can cause certain pigments to yellow, and second, the 1/4-inch thickness is strong enough to support the paint.

Masonite in larger sizes (over 30x30 inches) should be supported, for better handling and the prevention of curving, by a wood brace glued to the back of the panel. A 1x3-inch pine board cut to the exact size of the panel, reinforced with cross-braces (Figure 2–1), and glued with

Figure 2–1

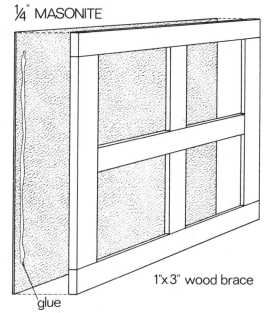

¼" MASONITE

1"x 3" wood brace

glue

an Elmer's ® -type white glue (emulsified **polyvinyl acetate**) to the back of the panel should provide a rigid support. After gluing, the Masonite and supporting wood should be clamped together until dry.

The preparation of the surface of the Masonite, a simple procedure, will be fully described in Chapter 3.

C.2 Plywood

Plywood is composed of thin sheets of birch or maple wood laminated under pressure to form a single unit. It is readily available, inexpensive, and suitable for painting. Plywood is less likely to split, crack, or warp than is a solid wood panel. Because it is available in many thicknesses, it does not need any wood support, unless, of course, it is an unusually large size. The method of preparing plywood for oil painting may be found in Chapter 3.

C.3 Canvas Board

Canvas board is a fabrication of a thin layer of cloth and cardboard glued together and coated with a thin film of gesso. It is not recommended for the serious artist because of its tendency to warp and because its availability is limited to small sizes. Even for preliminary oil sketches it is better and less expensive to use a good **chipboard** (inexpensive cardboard), preparing it, if necessary, with a coating of an acrylic gesso preparation.

In summary, hard supports have the disadvantage that all are limited in size and most get quite heavy, especially after the addition of supportive braces. Panels may also impose a storage problem, for unlike stretched canvas, the painting cannot be removed from its stretcher and rolled up.

D. PAPER

Some discussion on the use of paper as a painting support is appropriate here. A good paper—that is, one of 100 percent rag content—can be used as a painting support for oils provided that permanence is not required. The use of paper by students for oil sketches or studies is probably its most logical use.

Some artists recommend an application of glue size to the paper before painting, but I feel that since this does not significantly add to the paper's permanence extra preliminary steps are contraindicated. The advantage of paper is its accessibility and low cost.

Almost all art supply manufacturers offer a prepared (coated) paper product that is imprinted with a canvaslike texture that works well for oil sketches.

Paper, because it comes in a variety of textures, weights, and sizes and can be purchased in uncut rolls, is a likely material for student use. Needless to say, I am not recommending paper as a canvas substitute, but only as a supplemental material for painting notation.

If in the process of using oil on paper you notice an oil ring or stain around the color, try diluting the oil in the paint by adding a couple of drops of turpentine to it. Another way of solving this problem is to let the paint stand on a blotter before using it so that the excess oil may be absorbed. If you do not wish to tamper with the feel, **viscosity**, or texture of the paint, you may use a **rabbitskin glue** or **gelatine** size to coat the paper (1 ounce glue to 1 quart water)—not for per-

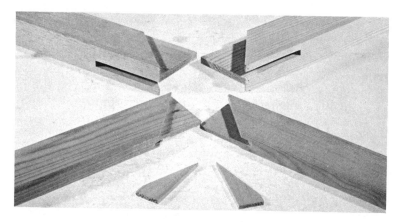

Figure 2–2

manency, but to reduce the absorbency of the paper. Follow the directions in Chapter 3 for the preparation of a glue size.

Gluing the paper to wood or Masonite is not a necessary prerequisite for painting. In fact, it tends to nullify the paper's main advantage as an immediate, temporary support for oil studies.

A relatively new product on the market manufactured by M. Grumbacher deserving special mention is Hypro® paper fabric. Quoting from the Grumbacher literature, it is a "nonwoven, absorbent paper/fabric of pure pH controlled alpha **cellulose** fibers in a sophisticated acrylic resin binding system which gives it exceptional tensile strength." Hypro may be used with oils in the usual manner or it may be attached to a stretcher like a fabric. If it is used as a spanned support, it should be sized with an acrylic paint varnish and an acrylic **gesso** ground. Instructions included with the paper fabric should be consulted for details concerning its use. Hypro has the great advantage of being available in sheets in sizes up to 24x36 inches, in pads up to 18x24 inches, and in

rolls 48 inches x up to 50 yards long. A ream (500 sheets each 22x30 inches) weighs 144 pounds.

E. WOOD STRETCHERS AND STRAINERS FOR CANVAS SUPPORT

Note: *The word* **stretcher** *is applied to those frameworks which have* expandable *corners. The word* **strainer** *is applied to those frameworks which have* fixed *corners.*

E.1 Manufactured Stretchers

Manufactured or commercially prepared wood stretchers account for the majority of stretchers in use today. They are generally created from kiln-dried clear pine. The ends are cut with a tongue-and-groove miter (Figure 2–2) that makes assembly with 90-degree corners a simpler matter to accomplish. A certain minimum amount of care should be exercised in the selection of the stretcher, paying particular attention that each individual stretcher strip or bar is free of warps or twisting. The ends should also be checked to make sure that

11

neither the tongue nor the groove side is cracked or chipped at its end. These simple precautions will save a great deal of time, effort, and frustration in preparing the finished product. One last word: when buying the stretcher bars, be sure to get the free **keys** or **wedges** that come with the set. There should be eight keys or wedges per stretcher set.

The manufactured stretcher bars are assembled by working the corners together by hand. Any final seating of the corners should be done by tapping with a mallet or piece of wood, but not directly on the grooved ends. The corners can then be checked against a 90-degree angle ruler (Figure 2–3) or placed inside a metal door jamb to see that all the corners are at a true right angle.

Frequently, when working with sizes over 36 inches, a heavier-duty stretcher

Figure 2–3

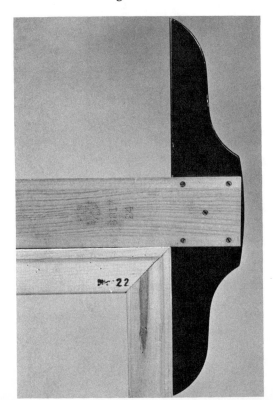
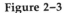

bar is needed. There are excellent supply houses and mail order houses that will have the extra-heavy-duty stretcher bars in stock, or they can be custom made to your order. However, the price is quite high when compared to making an adequate framework yourself. The one drawback to the homemade framework is that in most cases (see section of this chapter for exceptions) it cannot be expanded at the corners, while the manufactured tongue-and-groove stretcher bars can be "wedged" apart at each corner after the canvas is attached. This wedging is accomplished by inserting two wooden keys into the space provided at each corner of the manufactured stretcher. The keys can then be alternately tapped with a small hammer into the corners until each corner is spread apart equally.

This wedging procedure, which stretches the canvas taut, should be repeated whenever the canvas becomes slack during or after the painting process. Never use keys to take out wrinkles as this will distort the angle of the corners. Restretch wrinkled portion instead. Lack of adjustability in the corners of the homemade strainer will be somewhat compensated for by preparing the canvas after it has been attached to the constructed strainer. During the preparation of the canvas the application of a glue size or of an acrylic one-step gesso preparation will shrink the canvas tight.

E.2 Construction of Wood Strainers

There are several methods for constructing your own strainers, but they all have certain things in common. First, the wood selected should be free of knots, not warped or twisted, and kiln-

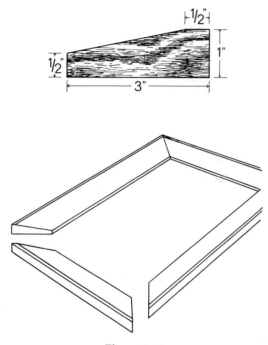

Figure 2–4

that the canvas be raised off the surface of the wood or that the wood be beveled *away* from the back of the canvas. This may be accomplished in any one of the following fashions:

Bevel-style strainer: This style of strainer requires the use of a table saw to bevel (cut a slice off the length of) a 1x3-inch board. A 1/2-inch margin or surface should be left on the face of the board as the "contact" area of the canvas on the wood (Figure 2–4). Use mitered corners on this kind of strainer.

Quarter-round-style strainer: If a table saw is not available, nail a strip of 1/2-inch *quarter-round* wood to the top surface of the strainer wood the following way:

STEP 1. Lay the fabricated strainer flat and place the 1/2-inch quarter-round mitred strip on top of it so that the outside edges are matched and the curved sides of the quarter-round strips face the inside of the strainer.

STEP 2. Apply a thin coat of white glue and nail each quarter-round strip to the strainer wood using 3/4-inch finishing nails (Figure 2–5).

dried; pine or redwood is excellent for stretchers. Another essential element is that the completed strainer should only come in contact with a small portion of the canvas that will be stretched over it. This element in the construction of the strainer is important enough to explain in greater detail.

If you were to use 1x3-inch wood boards in a configuration like a window screen — that is, laying the four boards flat and joining them at the corners — there would be 3 inches of wood touching the back of the canvas all around its perimeter. Then, during the act of painting there would be a good chance that you would pick up the line of the wood on the surface of the painting. This line is generally aesthetically displeasing and can even cause physical damage to the canvas. Therefore, it is recommended

Figure 2–5

3/4" finishing nails

1/2" quarter round molding

glue

1" x 3" board

13

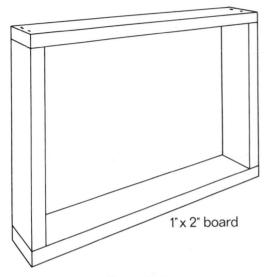

1"x 2" board

Figure 2–6

1x2-inch-board-style strainer: This last style of avoiding contact with a large portion of the canvas is to use 1x2-inch board (instead of 1x3-inch board) joined not while flat, but on its edge. This method is the simplest and most commonly used by students for making their own strainers. First, the wood is measured and cut. Next, the corners butt-joined in the way suggested in the next section. The complete frame will be 2 inches deep with only a 1-inch surface coming in contact with the canvas (Figure 2–6).

E.2(a) Strainer Corners

Joining the corners of the strainer should not present any unusual problems. The important characteristics of corners are that they be set at a 90-degree angle and not twisted in any direction. The type or style of joint is not particularly important as long as it is assembled properly. The artist may chose ei-

ther a butt (Figure 2–7), a mitered (Figure 2–8), or a notched corner joint (Figure 2–9). Be sure to use a set of four corner clamps during the joining process, for they can be a great aid in achieving rigid 90-degree angles.

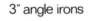

3" angle irons

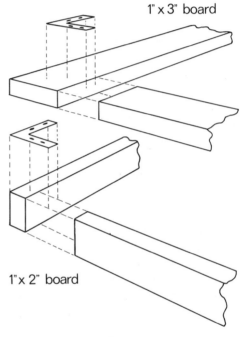

1" x 3" board

1"x 2" board

Figure 2–7

Figure 2–8

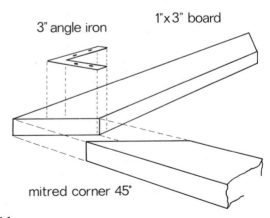

3" angle iron

1"x 3" board

mitred corner 45°

14

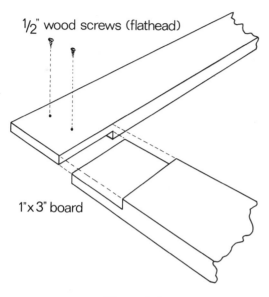

½" wood screws (flathead)

1"x 3" board

Figure 2–9

E.2(b) Bracing a Strainer

In order to prevent the strainer from sloping in at the sides, top, or bottom, a series of supports or braces will be necessary. The brace design will vary slightly depending on which of the three strainer styles mentioned above is used. In each case, however, the braces are made from the same stock as the strainer.

E.2(b.1) BRACING THE BEVEL-STYLE STRAINER

STEP 1. After the four corners are assembled, measure the distance between the inner edges of any two opposite sides.

STEP 2. Add 4 inches to this measurement. This will be the total length of the brace board between the two sides.

STEP 3. Measure in 2 inches from each end of the brace board and make a saw cut halfway through it. Then, from the board end, saw or chisel down to the cut (Figure 2–10).

STEP 4. The two ends having been notched, all that remains is to notch the center (on the opposite side) of the brace to accommodate the second (cross) brace.

STEP 5. Follow the same steps in creating the second (cross) brace — with the *exception* of the center notch, where the braces are joined, which should be made on the *same* surface as the two end notches.

Figure 2–11 shows a view of the two braces in relation to the strainer.

STEP 6. Assemble the cut braces and fit them onto the strainer. They should be snug against the strainer, but not so much as to cause the strainer to bow outward. Attach the braces to one another and to the strainer with flathead wood screws.

Figure 2–10

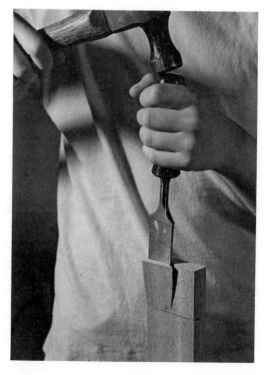

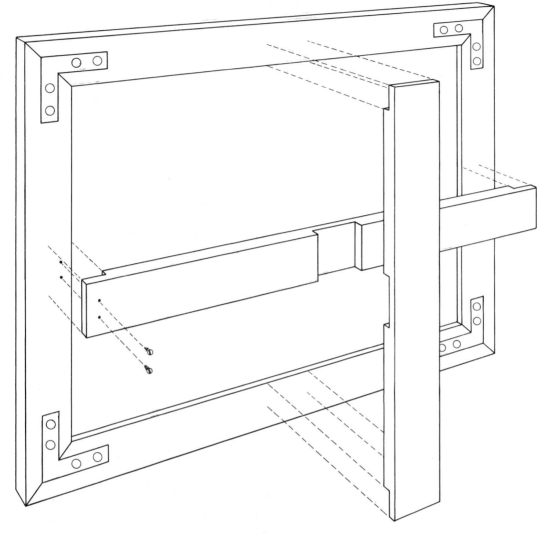

Figure 2–11

E.2(b.2) BRACING THE QUARTER-ROUND-STYLE STRAINER. The attached 1/2-inch quarter-round strips will prevent the stretched canvas from touching the strainer; therefore, the braces for this style need not be recessed by notching the ends. Simply cut one 1x3-inch board to fit between the vertical sides, another 1x3-inch board to fit between the horizontal brace board and the top of the strainer, and another 1x3-inch board to fit between the horizontal brace board and the bottom. Join all of the boards to one another and to the strainer with glue, and finally, add T-shape metal mending plates to the joints.

E.2(b.3) BRACING THE 1x2-INCH-BOARD-STYLE STRAINER

STEP 1. Place the fabricated 1x2-inch board strainer on a flat surface. As a matter of convenience, let us say that it is face down—lying on what will become the face side after the canvas is attached.

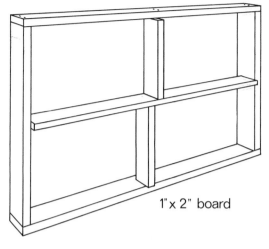

1" x 2" board

Figure 2–12

STEP 2. Measure and cut the horizontal brace board to the inside dimension of the sides of the strainer.

STEP 3. Arrange the brace board between the sides of the strainer. Then lift or raise the brace 1/4 to 3/8 inch off the flat surface and nail it in that position (through the outside of the strainer into the brace) with finishing nails.

The reason for lifting or raising the brace off the surface is so that it will be recessed when the strainer is right side up. This prevents the back of the canvas from rubbing against the brace.

STEP 4. The vertical bracing system can be divided into two parts to avoid having to notch it into the horizontal brace. Measure and cut a board to fit the dimension between the horizontal brace and the top board of the strainer. Arrange it in a centered position.

STEP 5. Lift or raise the brace as in Step 3, and nail it in place.

STEP 6. Repeat Steps 4 and 5 for the bottom half of the vertical brace. To allow space to hammer this brace piece to the horizontal brace, move this brace piece to the right or left of center. See Figure 2–12 for the completed strainer with braces.

E.3 Constructing a Home-Built Stretcher

There are several products (expandable corner hardware) on the market for making your own stretchers. While most require special tools and a great deal of woodworking skill, one inexpensive product requires only a miter box and a screwdriver: M. Grumbacher's Stretcher Cleats ® and Cross Bar Cleats ®

Figure 2–13

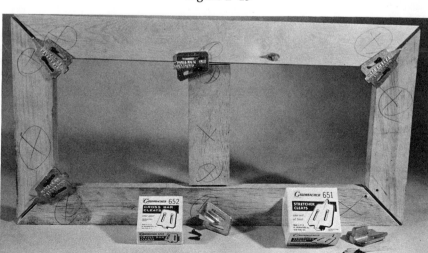

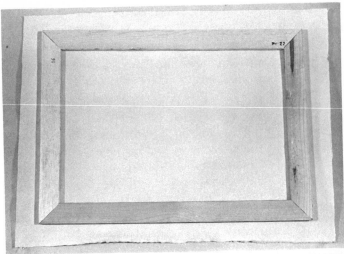

Figure 2–14

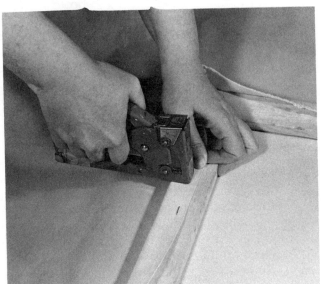

Figure 2–15

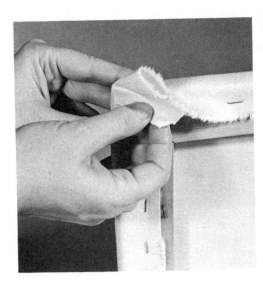

Figure 2–16

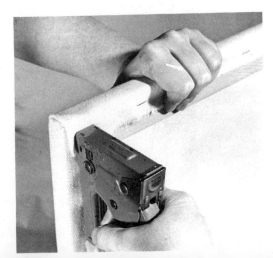

Figure 2–17

(see Figure 2–13). The corner Stretcher Cleat looks like a metal folded paper airplane. The winglike top is provided with slots so that the holding screws can be loosened and the edge slid deeper into the corners. The uniquely designed cleats not only join the corners, but provide the means to key the corners out *and* at the same time slant the wood inward (away from the face) to assure clearance of the stretched canvas. Very clear and complete instructions are included in each kit (cleats, screws, etc.), and so there is no need to repeat them here. I highly recommend these products, especially for student use.

F. ATTACHING THE CANVAS TO THE STRETCHER OR STRAINER

F.1 Method for Unprepared Canvas (unsized with no ground)

Attaching or stretching the unprepared canvas to the assembled stretcher bars or the strainer framework is described in the following steps:

STEP 1. Cut the canvas 2 inches larger than the wooden framework on all sides. This excess is provided to allow for handling during the attaching process.

STEP 2. Place the canvas flat on a table or the floor and smooth out any gross wrinkles with your hand. Minor wrinkles caused by the previous folding of the canvas will disappear as the canvas is shrunk by the application of the hot glue size.

STEP 3. Place the wooden framework in the center of the canvas (there is no right or wrong side of the canvas) so that the weave is parallel to the sides of the wooden framework (Figure 2–14).

STEP 4. Fold the canvas all the way around the sides to the back of the wooden framework; using a lightweight staple gun or an upholsterer's hammer (with no. 4 or 6 carpet tacks), attach the canvas to the back of the framework at 2-inch intervals (Figure 2–15). Do not stretch the canvas taut during this process, but merely pull it smooth, leaving some slackness to the finished product. Complete all sides by alternating the stapling or tacking from opposite side to opposite side, leaving the corners for last.

STEP 5. Fold the corners—see Figures 2–16 and 2–17.

STEP 6. Turn the canvas over (face up); the slightly slack canvas is now ready for the application of the hot glue size, which will shrink it taut. Do not trim any excess canvas.

Note: *If the acrylic one-step size-and-ground combination (see Chapter 3, B.2(a)) is to be used to prepare the canvas for painting instead of the hot glue process, the canvas may be pulled more tightly but left with just a "touch" of slackness.*

F.2 Method for Prepared Canvas

Attaching manufacturer-prepared canvas involves a different process. Because the canvas already has an application of size and ground (usually white paint) applied to it, it is much less flexible and needs to be stretched tautly over the wooden framework, be it a stretcher or a strainer. To attach the prepared canvas, a canvas-stretching pliers (Figure 2–18) is a necessary tool in addition to the staple

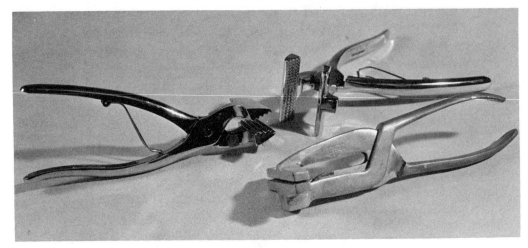

Figure 2–18

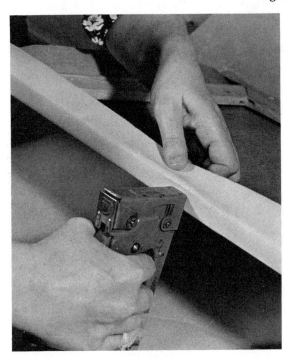

Figure 2–19

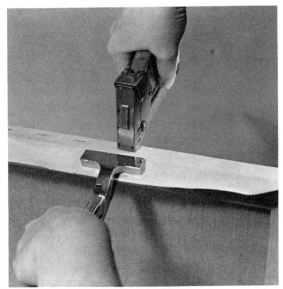

Figure 2–20

gun or hammer and tacks. The process described below applies regardless of whether a staple gun or hammer and tacks are used:

STEP 1. Cut the canvas 1 1/2 inches in excess of the amount needed to cover the sides (the **tack-over edge**) of the wooden framework.

STEP 2. Lay the canvas flat, prepared (**primed**) side down on a clean table.

STEP 3. Place the wooden framework

20

in the center of the canvas so that an equal amount of canvas extends beyond all sides.

STEP 4. Begin the attaching process in the center of each of the sides by stapling or tacking the canvas to the *side or edge* of the wooden framework (Figure 2–19). Hold the canvas taut.

STEP 5. Lift up the canvas and framework and place it on its edge. Staple or tack the canvas 2 inches on either side of the first staples or tacks (Figure 2–20).

STEP 6. Rotating from opposite side to opposite side, staple or tack at 2-inch intervals working toward the corners and using the canvas-stretching pliers to aid you in pulling the canvas tight. If you are right-handed, hold the pliers in your left hand and the staple gun or hammer in your right. Place the protruding shape on one jaw of the stretching pliers against the back of the wooden framework. As the canvas is gripped by the pliers, exerting a downward force will cause the protruding shape on the lower jaw to act as a lever and pull the canvas taut (Figure 2–21). Increase the tension on the pliers as you approach the corners.

Figure 2–21

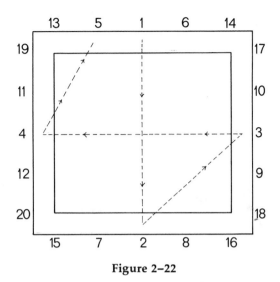

Figure 2–22

STEP 7. The stapling or tacking sequence should follow the order given in Figure 2–22 until the corners are reached. In general, pull the canvas slightly away from the center toward the corners. Working from behind the canvas, always check the front side during the process to see that unwanted horizontal folds are not being created.

STEP 8. When you reach the corners, fold the canvas as in Figures 2–16 and 2–17. If you are using a manufactured stretcher, be sure to drive the staple or tack into the wider portion of the mortised end's edge. By observing the upper stretcher bar from the back of the canvas, you will see that this wide portion of the mortised end is closer to the front face on the left end of the stretcher bar and closer to the back of the right end.

The canvas keys may be inserted by hand into each corner so that they will be available when necessary. They should not, however, be driven in deeply at this time. The canvas is now complete.

Note: *If the hammer-and-tack method is preferred over the staple gun, the best ham-*

mer to use is a double-headed upholsterer's hammer with one magnetized end. Using the magnetized split end of the hammer, you can pick up a tack by its head and strike the first blow, setting the tack into the framework in one motion. Then, loosening your grip, rotate the handle of the hammer to the solid head and drive the tack into the wood. Since your left hand will be holding the canvas taut with the stretching pliers, it is essential that picking up the tack and hammering it be accomplished with one hand.

Chapter three

SIZES AND GROUNDS

SIZES
AND GROUNDS

Chapter three

SIZES AND GROUNDS

A. SIZES

Sizing is the process by which the pores of the fabric (canvas) strands are sealed to isolate them from the corrosive or rotting action of oil paint. The size is generally made from a solution of glue or gelatin mixed with water, or in some cases the size may be an Acryloid® or **polymer** solution. The size coating is not intended to fill in the spaces between the weave or to create a continuous film layer on which to apply paint. The primary function of the size is to seal or coat the fibers so that they will not absorb any oil from subsequent layers of paint. A by-product of a glue or gelatin solution made with water and applied hot is the shrinking action it has upon the canvas. As previously discussed, the attached unprepared canvas should provide some slack to accommodate the shrinking process. If an Acryloid or polymer size is used, the unprepared canvas may be attached tautly.

Five size solutions, their preparation, and their application to the canvas are described in this section.

A.1 Animal-Hide Glue

Rabbitskin glue remains one of the most preferred glues for sizing. It is made in both America and France from the skins of rabbits and is packaged in dry form in sheets, granules, or semi-powdered. Because the glue is available in such a variety of forms, the following measurements will be given in dry ounces avoirdupois (av. or avdp.) weight. This means that a small postage scale should be used to measure the dry glue. If no scale is available, the dry glue may be poured into a graduated beaker partially filled with water until the water level rises (in volume) slightly more than the required amount of ounces of glue required by dry measure. In a given instance, because of the different density of each of the forms (sheets, granules, or powder) in which glue can be purchased, 1 ounce of glue *by weight* may or may not displace or raise the water level 1 ounce *by volume.*

To prepare and apply a glue size to unprepared canvas, follow the steps below:

STEP 1. Mix $1\frac{1}{2}$ to 2 ounces of dry rab-

bitskin glue *by weight* with 32 ounces of cold water *by volume* in a large jar.

STEP 2. Allow the jar to stand 3–4 hours to permit the glue granules or broken-up sheets to absorb and swell with water.

STEP 3. Pour the mixture into the top of a double boiler or an improvised double boiler (for example, a large coffee can set in a pot of water). Be sure the opening of the container is large enough to accommodate a 2- or 3-inch brush.

STEP 4. Heat the glue while occasionally stirring the solution to prevent the glue from sticking to the bottom.

STEP 5. Heat thoroughly until the glue dissolves into a thin, soupy solution. But *do not boil,* as this will weaken the structure of the glue.

STEP 6. Place the stretcher with the canvas attached on a flat table face up, and raise it off the surface with blocks of wood. This is necessary to prevent the back of the canvas from touching the table when the glue is applied. Fingers or objects touching the back of the canvas will cause the wet glue to seep through to the back of the canvas; later, when dry, this area will cause problems with the application of a gesso surface.

STEP 7. Start applying the hot glue with a 2- to 3-inch brush at the center of the canvas with a rapid brushing motion. Brush out in all directions with horizontal and vertical strokes, but do not expect to cover much area with each brush stroke. Continue brushing from the wet to dry areas until the whole surface is covered. Do not allow excess glue to puddle in one area of the canvas without brushing, because it will soak through the canvas and cause difficulties later. You will notice the shrinking action begins to occur almost as soon as the glue is applied (Figure 3–1).

STEP 8. Before the canvas is put aside to dry overnight, run a thin piece of cardboard, such as a matchbook cover, between the wood framework and the back of the canvas to prevent the canvas from sticking to the wood (Figure 3–2).

Figure 3–1

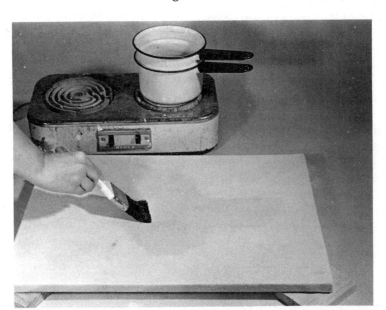

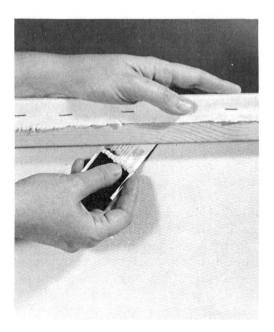

Figure 3–2

STEP 9. When the canvas is thoroughly dry, give the surface a very light sanding with very fine sandpaper to remove the stiffened threads. Be careful not to sand excessively, thereby weakening the fiber itself.

STEP 10. When the remaining glue cools in the pot, it should resemble the appearance of chunky applesauce. It may be stored in a tightly sealed jar, and may be reheated and reused one more time. A word of caution, however: the stored glue will decompose within a brief period of time and should be used or disposed of within a week or two.

STEP 11. To reduce the characteristic susceptibility of rabbitskin glue (and gelatin) to mold and fungus growth, a 4-percent solution of **formaldehyde** may be brushed on both sides of the canvas after the size has dried.

A.2 Gelatin

Gelatin is an organic protein material that is derived from animal ligaments, bones, skin, and so on. It is considerably more refined than rabbitskin glue and makes a suitable size for the preparation of a canvas. Gelatin is available in granular or sheet form and can be purchased from a scientific (chemical-biological) supply house. Powdered edible gelatin, the variety sold in supermarkets, is also suitable for use.

The procedure for mixing the gelatin and applying it to the canvas is the same as the procedure for rabbitskin glue (Section A.1). The formula for a gelatin size solution is approximately the same as that for rabbitskin glue—i.e., $1\frac{1}{2}$ to 2 ounces of dry gelatin by weight to 32 ounces of water by volume.

A.3 Acryloid ® B-72, Polymer Emulsions, and Polyvinyl Acetate (PVA)

A.3(a) Acryloid B-72

Acryloid B-72 is a product of Rohm and Haas supplied in a 50-percent solid resin solution of toluol. While Acryloid B-72 is soluble in toluol, it is unaffected by artists' materials such as turpentine and mineral spirits, and is thus suitable to use as a sizing solution.

Acryloid B-72 is prepared for use as a sizing solution by diluting the commercial concentrate in the ratio of two (2) parts toluol to one (1) part Acryloid B-72. This formula will thin or "cut" the Acryloid B-72 to a brushable solution. It does not have to be heated like rabbitskin or gelatin glue and may be brushed directly onto the tautly stretched canvas.

A.3(b) Polymer Emulsions

Polymer emulsions are sold under various artists' supply companies' trade names and are generally known as mat medium. It is the medium that is designed to be used with most polymer paints and is readily available where artists' supplies are sold.

Polymer emulsions (mat medium) are thinned with water and when dry are impervious to the normal materials of oil painting. To use polymer emulsion as a sizing solution, it should first be thinned in the proportion of one (1) part water to one (1) part polymer emulsion. It should be applied, unheated, to a tautly stretched canvas.

A.3(c) Polyvinyl Acetate (PVA)

Polyvinyl acetate (PVA) is commonly available as white glue (Elmer's Glue-All®). As a size for canvas, PVA should be thinned in the ratio of one (1) part water to one (1) part PVA and applied, unheated, to tautly stretched canvas.

In summary, when deciding upon which size solution to use, the following facts should be considered: PVA, polymer emulsions, and Acryloid B-72 do not have to be heated and do not organically decompose, but they cost more and do not shrink the canvas taut as they are applied. The shrinking process may be viewed as an asset or as a disadvantage depending on how the artist prefers to work.

In many schools or styles of painting artists prefer to paint directly on the sized canvas without the application of a ground. This decision is usually motivated by a desire to preserve the natural color and appearance of the canvas and/or to create an aesthetic unity between the image and the support. There is actually no chemical reason for applying a white paint layer (ground) before painting. The white paint layer does, however, provide a physical base, an isolating or intermediate layer between the fabric and the image paint layers that reduces the absorbency of those subsequent layers and provides a maximum reflective surface for creating transparent effects. However, these properties may not fit the aesthetic outlook of the artist.

Painting on a surface without a ground may begin after proper application of any of the five sizing solutions listed above. The particular sizing solution used will to some extent determine the response of the canvas to the brush and the appearance of the finished product. The chief contributing factor here is the solution's absorbency rate. Therefore, the artist must experiment with the various solutions until he finds one that is compatible with his style.

B. GROUNDS

With the exception noted two paragraphs above, the application of a ground is the next step in the preparation of a canvas for oil painting. A ground is a layer of paint applied to the dried sized canvas. Its function is to fill the gaps between the weave of the canvas and provide a suitable uniform surface with the desired degree of absorbency on which to paint. Grounds are usually white so as to provide a maximum reflective surface that will contribute to the luminosity of subsequent layers of paint.

There are two very different materials in common use today as grounds: the traditional white lead oil paint and the newer acrylic polymer emulsion known as polymer gesso, acrylic gesso, or one-step gesso.

B.1 White Lead Oil Paint (basic carbonate of lead)

The traditional method for preparing a sized canvas for painting includes two priming coats of white lead oil paint. A suitable grade of white lead paste (approximately 90 percent basic lead carbonate plus approximately 10 percent raw linseed oil) was formerly available in retail paint supply stores until a recent federal government restriction on its sale. The restriction is based on the fact that the poisonous white lead is dangerous, especially when inhaled in powdered form or ingested in any form. However, artist's paints that contain white lead and white lead paste for artist's use are exempt from this restriction. The manufacturer's wording on the label is the determining factor for exemption.

Reliable professional artist's color manufacturers, being sensitive to the needs of artists, are beginning to label and package white lead paste in larger quantities for use in preparing a canvas for painting. One such manufacturer is Bocour Pigments.

B.1(a) Procedure for Applying White Lead Oil Paint

STEP 1. Place the canvas, already sized with an appropriate sizing solution, dried, and lightly sanded with very fine sandpaper, horizontally on a flat surface.

STEP 2. Extract the white lead paste from its container and thin it with turpentine or mineral spirits. If you are using the white lead in concentrated paste form, $1\frac{1}{2}$ to $2\frac{1}{2}$ ounces of turpentine to 1 pound of paste will give you the proper brush consistency. If you choose, you may apply the white lead with a broad-blade (6 inches long) **painting knife**, in which case the paste when applied should have a slightly thicker consistency.

Note: *If you use artist's quality white lead in a 1-pound tube, less turpentine will be needed to thin it to the proper consistency. Too much thinning will produce a weak, excessively absorbent surface. Too little thinning makes the white lead too stiff to apply and produces a glossy, nonabsorbent surface.*

One pound of white lead does not cover very much area (approximately 500–600 square inches), so do not hesitate to thin a sufficient batch of white lead for the complete job. Thinning a little white lead at a time will result in an inconsistent surface.

STEP 3. Apply the white lead paint to the canvas in both directions, forcing the paint into the weave of the canvas and ending with a finishing stroke going in one direction (Figure 3–3). When applying the paint to the surface near the sides, it is best to raise the canvas gently with your hand from the back to avoid a scrape mark when your tool passes over the wood support. The edges or sides of the canvas should be covered with paint as well.

After two or three days, when dry to the touch, an optional second coat of the same consistency may be applied. An ex-

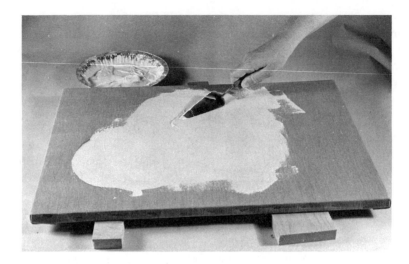

Figure 3–3

tremely light sanding between coats will help guarantee a smooth final surface.

STEP 4. After one or two coats of paint have been applied, allow the canvas to dry for two weeks before painting on it. The canvas should be placed to dry in natural light and not in the dark. White lead which has dried in the dark will turn yellow.

STEP 5. Wash your hands thoroughly with soap and water when finished and keep the remaining white lead oil paint out of reach of children and pets.

Note: *White lead is still preferred over other white paints (zinc white and titanium white) for studio preparation because of its soft white color, ease of application, brushing quality, and tough, flexible final film.*

B.2 Acrylic Polymer Emulsion

Many manufacturers offer a synthetic resin ground for the one-step preparation of a canvas. The acrylic polymer emulsion is applied directly to the stretched canvas and eliminates the need for an application of a sizing solution. It is sold under various brand names, such as Liquitex Gesso ® (Permanent Pigments), New Temp Gesso ® (Utrecht Linens), and Hyplar Gesso ® (M. Grumbacher).

B.2(a) Procedure for Applying the Acrylic Polymer Emulsion

STEP 1. Stretch the canvas as described in Chapter 2, F.1, so that there is a slight "give" or a little slack in it. The emulsion has a slight shrinking action when applied.

STEP 2. Apply the emulsion directly from the can with a 3-inch-wide brush. Brush on a small area at a time going in all directions (Figure 3–4) with a finishing stroke in one direction to eliminate any large brush marks. Work from wet areas to dry areas and cover the edges of the canvas as well. Thinning the emulsion is not usually required; even though it may have a thick, creamy look in the

30

can, it will brush out very smoothly. If it is necessary to thin the emulsion, use very little water. Excessive thinning to extend the amount of emulsion will be defeated by the necessity to apply additional coats.

STEP 3. When the canvas is dry, sand it very lightly with fine sandpaper to remove the stiffened little fabric threads. Apply a second coat of the emulsion; when this dries, sand lightly again and the canvas is ready for use.

B.2(b) *Application to a Rigid Support*

The acrylic polymer emulsions have all but replaced the traditional **glue-gesso** made of whiting mixed with a rabbit-skin glue that was formerly used to pre-pare panels and other rigid supports. Since the glue-gesso is primarily used as a preparation for nonoil techniques (especially egg tempera), its preparation and application will not be discussed in this text.

The acrylic polymer emulsions are suitable for use in preparing any of the rigid supports listed in Chapter 2, namely Masonite, plywood, cardboard, and paper. The acrylic polymer emulsion is simply brushed on directly from the can onto the Masonite or plywood without the application of a sizing solution. Two or three coats with light sanding in between are recommended. Where supporting braces are called for, they should be attached before applying the emulsion.

Figure 3–4

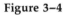

Chapter Four

OIL PAINTS, OILS, AND SOLVENTS

A. **INTRODUCTION**
 1. **Permanence**
 2. **Paint film**
 3. **Light fastness**
 4. **Stability**
 5. **Drying rate**
 6. **Brushing**

B. **COLOR PIGMENTS**
 1. **Organic (Containing Carbon)**
 a. *Fish and vegetable sources*
 b. *Animal sources*
 c. *Synthetic organic sources*
 2. **Inorganic (Mineral)**
 a. *Natural mineral pigments (earths)*
 b. *Calcined natural mineral colors (earths)*
 c. *Synthetic (manufactured) mineral pigments*

C. **OIL COLORS (PAINTS)**
 1. **Quick Reference Chart**

D. **INERT MATERIALS**
 1. **Aluminum Hydrate**
 2. **Aluminum Stearate**
 3. **Barium White**
 4. **Blanc Fixe**
 5. **Whiting**
 6. **Chalk (precipitated chalk)**

E. **WAXES**
 1. **Beeswax**
 2. **Carnuba Wax**
 3. **Microcrystalline Wax**

F. **DRYING OILS**
 1. **Cold-pressed Linseed Oil**
 2. **Hot-pressed Raw Linseed Oil**
 3. **Hot-pressed Refined Linseed Oil**
 4. **Sun-thickened Linseed Oil**
 5. **Stand Linseed Oil**
 6. **Poppy Seed Oil**
 7. **Safflower Oil**
 8. **Walnut Oil**

G. **VARNISH RESINS**
 1. **Copal Resin**
 2. **Dammar (or Damar) Resin**
 3. **Mastic Resin**
 4. **Acryloid® B-72**
 5. **Acryloid® B-67MT**

H. **SOLVENTS AND DILUENTS**
 1. **Turpentine (pure Gum Spirit Turpentine)**
 2. **Mineral Spirits (White Spirits, odorless Paint Thinner)**
 3. **Benzine**
 4. **Xylene**

Chapter Four

OIL PAINTS, OILS, AND SOLVENTS

A. INTRODUCTION

The terms *pigment* and *paint* are often used interchangeably. For our purposes, *pigment* will denote the material or substance that gives the paint its color and characteristics, and *paint* the pigment mixed with a liquid vehicle. Generally, the same pigments are used to make oil paint, water colors, pastels, tempera, and so forth; it is only the vehicle that is different in each case. The pigment becomes oil paint when it is ground or **mulled** with oil, usually linseed and/or poppy seed oil.

The principle is to find a vehicle or medium in which the pigment will not be soluble (will not dissolve), but will rather be held in suspension. If the pigment begins as a liquid in solution, it is known as a **dye**—that is, a chemically produced or natural color in solution. If this dye is then **precipitated** or fixed upon an **inert** material, usually aluminum hydroxide, it is called a **lake**. Lake making is usually done to give the pigment body so that it can be ground and mixed with the oil to make paint. Thus synthetic organic alizarin dye is made into a suitable artists' paint by precipitating it onto aluminum hydroxide particles and grinding the latter in a linseed oil vehicle. A **toner** is a concentrated lake containing very little inert material.

The result of grinding or mulling the pigment in an oil base is that the dry pigment clusters are dispersed and suspended evenly throughout the oil vehicle. Ground to the proper consistency, the pigment becomes paint and is ready for application to a prepared surface.

Some of the general requirements of an oil paint are:

1. *Permanence*—The paint should not disintegrate or decompose under normal conditions on its own accord. Under optimum conditions, the paint could last for several hundred years.

2. *Paint film*—The dried paint should produce a continuous, flexible, and durable film.

3. *Light fastness*—The dried paint should not fade or change color under normal exposure to light.

4. *Stability* — The paint should not bleed or leach through subsequent layers of paint and/or affect neighboring paint.

5. *Drying Rate* — The paint should dry in a reasonable time (20 days maximum) and yet not dry too rapidly (48 hours minimum).

6. *Brushing* — The paint should brush out evenly, smoothly, and easily, and leave a characteristic brush stroke.

B. COLOR PIGMENTS

Pigments are classified according to chemical composition and are named after either their source of origin or their chemical composition. Unfortunately, paint manufacturers frequently invent names for paints or use a name for its color connotation rather than for indicating the paint's true ingredients. Hence, a paint labeled "Rose Madder" may not be a genuine lake pigment made from the dried and ground root of the plant *Rubia tinctorum*, but rather a synthetic (alizarin) dye. This fact emphasizes the importance of the proper labeling of ingredients on paint containers.

Pigments can be divided into two major groups, each with subdivisions, as follows:

B.1 Organic (Containing Carbon)

(a) Derived from animal and vegetable sources, examples being sepia (from the ink sacs of cuttlefish) and madder (from a plant root)

(b) Derived from animal sources, an example being Indian yellow (from Indian cow urine)

(c) Synthetic (manufactured) organic sources, examples being phthalocyanine blue (and green) and alizarin crimson

Note: *Most of the pigments made from vegetable and animal sources either lack permanence or are too costly to manufacture and so have now been replaced by permanent synthetic organic pigments that are equivalent in color.*

B.2 Inorganic (Mineral)

(a) Natural mineral pigments (earths), examples being raw sienna, raw umber, and yellow ochre

(b) **Calcined** (burnt or roasted) natural mineral colors (earths), examples being burnt umber and burnt sienna

(c) Synthetic (manufactured) mineral pigments, examples being cadmium and cadmium-barium red, orange, yellow, zinc white, all Mars pigments, viridian green, and cobalt blue

C. OIL COLORS (PAINTS)

The following list consists of a selection of pigments in different color groups. As oil paints they are generally available from a variety of artist's paint manufacturers. Most of the pigment names and composition conform to the U.S. federal government's *Commercial Standard C598-62, Artist's Oil Paints* (available from the Superintendent of Documents, U.S. Government Printing Office, Washington, D.C.).

Under normal conditions, the following pigments are considered permanent when ground with oil to make paint. The

beginning student of painting may select a supply of paints from this list. A very basic but recommended selection is indicated by an asterisk. Wherever possible, the recommended selection of paints consists of a transparent and opaque paint from each of the color groups. This basic selection will allow the student the minimum number of paints to pursue the techniques described in Chapter 6.

1. *White*
 (a) Flake (also called Cremnitz) or lead white
 (b) Zinc white*
 (c) Titanium white*
 (d) Zinc/titanium mixture
2. *Black*
 (a) Ivory black*
 (b) Mars black
 (c) Lamp black
3. *Red*
 (a) Alizarin crimson*
 (b) Mars red
 (c) Cadmium red*
 (d) Indian red
4. *Orange*
 (a) Cadmium orange*
5. *Yellow*
 (a) Cadmium yellow*
 (b) Hansa yellow
 (c) Naples yellow
 (d) Yellow ocher*
6. *Green*
 (a) Phthalocyanine green
 (b) Cobalt green
 (c) Viridian green*
 (d) Chromium oxide green*
7. *Blue*
 (a) Phthalocyanine blue
 (b) Ultramarine blue*
 (c) Cobalt blue
 (d) Cerulean blue
 (e) Manganese blue*
8. *Violet*
 (a) Cobalt violet*
 (b) Manganese violet
 (c) Mars violet
 (d) Quinacridone magenta*
9. *Brown*
 (a) Raw umber*
 (b) Burnt umber*
 (c) Raw sienna
 (d) Burnt sienna*
 (e) Mars brown*

C.1 Quick Reference Chart: Common Oil Paints

On the accompanying chart, the following data is given:

Name: The commonly accepted name of the oil paint with synonyms indicated in parentheses. Proprietary names (paint companies' trade names) are indicated by the trademark character[tm], and the manufacturer is listed in brackets.

Pigment: The composition of the pigment material and its chemical formula

Place and Date of Origin: Specific where possible, otherwise generalized. Pigments are often discovered at an early date but not used in oil paint until sometime later

Appearance: A description in common terms of how the paint looks when squeezed directly from the tube and applied to a white canvas

Light-Transmission Property: The general degree of transparency when placed on white canvas

Tinting Strength: The tinctorial power

COMMON OIL PAINTS

Name	Pigment	Place and Date of Origin	Appearance	Light-Transmission Property	Tinting Strength	Permanence	Paint Film Characteristics	Comments
Flake white (Silver white) (Cremnitz white) (Lead white)	Basic lead carbonate [2PbCO$_3$·Pb(OH)$_2$]	Ancient	Warm (yellowish) white	Opaque	Medium	A	Flexible, durable	Poisonous; when unvarnished will darken upon exposure to sulfur fumes; good brushing qualities.
Zinc white (Chinese white)	Zinc oxide (ZnO)	France, late 18th c.; not in popular use until 1830s	Cool (bluish) white	Semi-transparent	Low	AA	Brittle, hard	
Titanium white (Titanox)	30% Titanium dioxide (TiO$_2$) mixed w/barium sulfate (BaSO$_4$)	U.S. & Norway, 1916–1919	Brilliant, intense white	Very opaque	High	AA	Soft	Slow-drying in oil
Zinc/Titanium Mixture (Composite white) (Permanent whitetm [Winsor & Newton]) (Permalbatm [Weber])	Titanium dioxide (TiO$_2$) and zinc oxide (ZnO)	U.S. & Europe, 1920	Bright white	Opaque	Medium	AA	Flexible	Produces a better paint film than either zinc or titanium alone; good brushing qualities; used as a ground in commercial preparation of canvas
Ivory black	Amorphous carbon (C) (charred animal bones) C + Ca$_3$(PO$_4$)$_3$	Ancient	Cool (bluish) black	Transparent	Medium	AA	Soft	High quantity of oil needed to grind into paint; when used directly should be used in

Name	Composition	Origin/Date	Color	Opacity	Tinting strength	Permanence	Durability	Remarks
Mars black	Ferro-ferric oxide (Fe_2O_3+FeO)	Europe, 19th c.	Warm (brownish) black	Very opaque	High	AA	Durable	moderation and never in underpainting
Lamp black	Pure amorphous carbon (C) (soot of burning oils, tars)	Prehistoric	Cool (bluish) black	Transparent	Medium	AA	Soft	
Alizarin crimson	1-2-dihydroxy-anthraquinone and aluminum hydroxide [Al(OH)$_3$]	Germany, 1868	Bluish red	Very transparent	Low	A	Soft	First synthetic lake; replaces the organic (vegetable) madder-root lake
Mars red	Artificial ocher and iron oxide plus aluminum oxide (Fe_2O_3+Al_2O_3)	Mid-19th c.	Brownish red	Opaque	High	AA	Durable	More consistent in color than the natural mineral (earth) ochers; fewer impurities
Cadmium-(CP – chemically pure)	Cadmium sulfo-sulfoselenide (CdS+CdSe)	U.S., 1907	Brilliant red	Opaque opaque	Medium	AA	Durable	Cadmium re-medium, deep
Cadmium-barium red	Cadmium sulfoselenide coprecipitated with barium sulfate (CdS+CdSe+BaSO$_4$)	U.S., 1926	Brilliant red	Opaque	Medium	AA	Durable	Cadmium reduced with barium for economy (student-grade paint); has same characteristics as a CP cadmium but with less tinting strength

Name	Pigment	Place and Date of Origin	Appearance	Light-Transmission Property	Tinting Strength	Permanence	Paint Film Characteristics	Comments
Quinacridone red (Acra red ® [Permanent Pigment]) (Permanent Rose ® [Winsor & Newton])	Linear quinacridone compounds $C_{20}H_{12}O_2N_2$ (gamma)	Germany, 1930–1940; U.S., 1950s	Intense, vivid red, slightly bluish	Very transparent	Medium	A	Flexible, durable	
Quinacridone red (scarlet)	Linear quinacridone compounds $C_{20}H_{12}O_2N_2$ (gamma)	Germany, 1930s; U.S., 1950s	Yellowish (red-orange), intense red	Very transparent	Medium	A	Flexible, durable	
Red oxides: Indian red, Light red, English red, Spanish red, Venetian red	Iron oxide (Fe_2O_3) (natural or artificial)	Natural—prehistoric; artificial —19th c.	Varies with each color, especially when mixed with white	Very opaque	High	AA	Durable	
Cadmium orange (CP)	Cadmium sulfide (CdS) or cadmium sulfoselenide (CdS + CdSe)	England, 1846	Intense, brilliant orange	Very opaque	High	A	Durable	
Cadmium-barium orange	Cadmium sulfide or cadmium sulfoselenide co-precipitated with barium sulfate (CdS + CdSe) + $BaSO_4$	U.S., 1927	Brilliant orange	Opaque	Med. high	A	Durable	See comments for cadmium-barium red

40

Name	Composition	Origin/Date	Color	Opacity		Rating	Durability	Comments
Cadmium yellow (CP) (CdS)	Cadmium sulfide (CdS)	Germany, England, France, 19th c.	Intense, brilliant yellow	Very opaque	High	A	Durable	Available in light, medium, and dark colors
Cadmium-barium yellow	Cadmium sulfide coprecipitated with barium sulfate ($CdS+BaSo_4$)	U.S. 1927	Brilliant yellow	Opaque	Med. high	A	Durable	See comments for cadmium-barium red
Hansa yellow	Substituted phenyl amine with an aceto-acetarylide	Germany, early 20th c.	Pale, bright yellow	Semi-transparent	Low	AA	Durable	
Naples yellow	Lead antimoniate $Pb_3(SbO_4)_2$ (essentially)	Ancient	Pale, earthy yellow	Semi-opaque	Low	A	Durable	Poisonous; good brushing qualities
Yellow ocher	Mix of hydrous iron oxide with alumina and silica $Fe_2O_3 \cdot H_2O$	Pre-historic	Dull (greenish) yellow	Opaque	Low	AA	Durable	
Phthalocyanine green (Winsor Green [Winsor & Newton] (Bocour Green [Bocour]) (Thalo Green [M. Grumbacher])	Chlorinated copper phthalocyanine	England, 1938	Brilliant, intense (bluish) green	Transparent	High	A	Durable, hard	Very intense, clear green
Cobalt green	Combined oxides of zinc and cobalt ($CoO \cdot nZnO$)	Sweden c. 1780	Blue-green	Opaque	Low	A	Flexible, semihard	

COMMON OIL PAINTS, Continued

Name	Pigment	Place and Date of Origin	Appearance	Light-Transmission Property	Tinting Strength	Permanence	Paint Film Characteristics	Comments
Viridian green (Chromium oxide, transparent) (*Vert emeraude*)	Hydrous chromic oxide $(Cr_2O_3 \cdot 2H_2O)$	France, 1838	Brilliant (bluish) green	Transparent	Medium	A	Semihard	Not as intense as Phthalocyanine green, but similar in color
Chromium oxide green	Anhydrous chromic oxide (Cr_2O_3)	France, 1862	Dull, dense green	Opaque	Low	AA	Semihard, flexible	
Phthalocyanine blue (Thalo Blue[tm] [M. Grumbacher]) (Bocour Blue[tm] [Bocour]) (Winsor Blue[tm] [Winsor & Newton])	Copper phthalocyanine	England, 1935	Intense, bright blue	Transparent	Very high	A	Hard, durable	
Ultramarine blue, artificial (French ultramarine) (Permanent blue)	Complex silicate of sodium and aluminum with sulfur $Na_{8-10}Al_6 Si_6O_{24}S_{2-4}$	France, 1828	Bright blue	Transparent	Medium	A	Semihard, brittle	Natural ultramarine, made with the semiprecious mineral lapis lazuli, is rarely found on the market; when mixed with white displays a slight violet tone
Cobalt blue (Thenard's blue)	Oxides of cobalt and aluminum $(CoO \cdot Al_2O_3)$	France, 1802	Bright clear blue	Transparent	Low	AA	Brittle	Frequently replaced with a cobalt hue of

Name	Composition	Origin, date	Color	Opacity	Tinting strength	Permanence	Hardness	Remarks
								ultramarine; when mixed with white has a slight greenish tone
Cerulean blue	Oxides of cobalt and tin ($CoO \cdot nSnO_2$)	England, 1860	Slightly greenish blue	Opaque	Low	AA	Soft	When mixed with white has a greenish tone
Manganese blue	Barium manganate with barium sulfate, ($BaMnO_4 + BaSO_4$)	France, 1935	Greenish blue	Semi-transparent	Very low	A	Durable	
Prussian blue (Paris blue) (Milori blue) (Chinese blue)	Ferric ferrocyanide $Fe_4[Fe(CN)_6]_3$	Germany, 1704	Deep, intense (greenish) blue	Transparent	High	A	Hard	Has a bronze sheen when applied in many layers
Cobalt violet (dark)	Anhydrous cobalt phosphate $[CO_3(PO_4)_2]$ or arsenate $[Co_3(AsO_4)_2]$	France, 1859	Reddish violet	Semi-transparent	Very low	AA	Brittle	Cobalt arsenite poisonous, but cobalt phosphate nonpoisonous; cobalt violet has a very reddish (magenta) appearance, is nearly transparent with very low tinting strength
Manganese violet (Permanent violet) (Mineral violet) (Nürnberg violet)	Manganese ammonium phosphate ($MnNH_4PO_4$)	Germany, 1868	Slightly bluish violet	Semi-transparent	Low	A	Durable	
Mars violet	Artificial iron oxide (Fe_2O_3)	Approx. 1850s	Dull (brownish) violet	Opaque	High	AA	Durable	When mixed with white shows as bluish violet

COMMON OIL PAINTS, Continued

Name	Pigment	Place and Date of Origin	Appearance	Light-Transmission Property	Tinting Strength	Permanence	Paint Film Characteristics	Comments
Magenta	Rhodamine toner $C_{26}H_{26}N_2O_3C_1$	Germany, 1892	Brilliant (reddish) violet	Semi-transparent	Low	C		Fugitive
Quinacridone violet	Linear quinacridone compounds $C_{20}H_{12}O_2N_2$ (beta)	Germany, 1930–1940; U.S., 1950s	Intense bright (reddish) violet	Transparent	Medium	A	Durable	
Mauve, red and blue	Aniline dye	England, 1856	Brilliant (reddish or bluish) violet	Transparent	Low	C	Soft	Fugitive
Raw sienna	Natural earth, hydrous silicates, and oxides of iron $Fe_2O_3 \cdot H_2O$	Ancient	Golden or yellowish brown—not as greenish as yellow ocher	Transparent	Low	AA	Durable	Frequently listed as a yellow pigment
Burnt sienna	Calcined raw sienna Fe_2O_3	Ancient	Rich (reddish) brown	Transparent	Low	AA	Durable, hard	

Name	Composition	Date	Color	Transparency		Rating	Durability	Notes
Mars brown	Artificial ocher and iron plus manganese oxides ($Fe_2O_3 + MnO_3$)	Mid-19th c.	Dull brown	Semi-transparent	Low	AA	Durable	
Raw umber	Natural earth hydrous oxides and silicates of iron and manganese $Fe_2O_3 + MnO_2 + H_2O$	Ancient	Distinctive greenish brown	Semi-transparent	Low	AA	Durable, flexible	
Burnt umber	Calcined raw umber $Fe_2O_3 + MnO_2$	Ancient	Rich, deep (reddish) brown	Semi-transparent	Low	AA	Durable, flexible	More transparent than raw umber
Van Dyke brown (Cassel earth) (Cologne earth)	Clay-iron oxide and decomposed humus and bitumen	17th c.	Deep, dark brown	Semi-transparent	Low	B	Very soft, weak	Subject to fading, cracking, and wrinkling; not recommended; fugitive in thin glazes

of the paint when mixed with white. If a small amount of the paint changes the white significantly, the tinting strength is said to be high; if there is little effect on the white, the tinting strength is low; and so forth.

Permanence:

Class AA: Paints that are absolutely permanent.

Class A: Paints that are permanent under normal conditions (not subject to certain fumes or abnormal exposure to direct sunlight).

Class B: Paints that are moderately permanent

Class C: Paints that are **fugitive** — that is, that either change color, fade, or bleed (leach) into neighboring paints, affecting their color or the color of subsequent paint layers placed over them

Paint Film Characteristics: The quality of the dried paint film when used directly from the tube — that is, its durability, flexibility, and so on.

Comments: Any notes of interest or additional information pertaining to characteristics or properties not mentioned under other headings.

D. INERT MATERIALS

Many common inert materials, sometimes referred to as inert pigments, are added to or used in the manufacture of paint. They are usually in the form of white, fluffy particles not in themselves suitable for making white paint, because the particles become almost colorless and transparent when ground in oil. They are used to modify other pigments so that the latter may be better suited for the making of oil paint. Some inert materials improve the consistency of the paint, discourage the separation of the pigment from the oil, or cut the intensity of the pigment. Inert materials are commonly used in the lake-making process where the liquid dye is precipitated onto or fixed upon the inert material, thus giving the dye body and the ability to be ground in oil.

Some inert materials can be used to extend or reduce the amount of pigment in paint. Used in this manner as an **extender**, the inert material creates an inferior paint of weakened concentration.

The following are the most common inert materials ("inert pigments"):

D.1 Aluminum Hydrate

Material: Artificial aluminum hydroxide Al $(OH)_3$

Source: Result of treating a solution of sulfate with an **alkali** (e.g., potash or soda ash)

Description: Light, white powder when dry; transparent and colorless when ground in oil

Used as:

(a) A base for dyes in the manufacture of lakes

(b) A modifier in the manufacture of oil paints to improve the consistency of certain pigments

(c) An extender (replacing a proportion of pigment) particularly for transparent pigments because of its transparent nature when ground in oil.

Disadvantages: Excessive use as an extender (more than 2 percent by volume) weakens color con-

centration and tinting strength of the paint

D.2 Aluminum Stearate

Material: A soap, Al $(C_{18}H_{35}O_2)_3$

Source: **Saponified** (boiled with an alkali — e.g., alum) tallow (fat)

Description: White powder, gels when mixed with oil, turpentine, or mineral spirits

Used as: A **stabilizer** in the manufacture of oil paint to discourage the separation of the pigments and the oil

Disadvantage: Used in excess, creates a soft, slow-drying paint film

D.3 Barium White

Material: Natural barium sulfate $(BaSO_4)$

Source: The mineral barite

Description: Transparent, coarse powder

Used as: An extender and modifier in the manufacture of oil paints

D.4 Blanc Fixe

Material: Artificial barium sulfate $(BaSO_4)$

Source: Formed by precipitation from barium chloride solution with sodium sulfate

Description: White powder

Used as:

(a) A base for the more opaque lakes

(b) An extender for oil paints

Advantages: A more finely divided powder and more opaque than the natural barium sulfate

D.5 Whiting

Material: Natural calcium carbonate $(CaCO_3)$

Source: Fossil deposits formed by the remains of minute sea organisms; ground and washed it becomes a powder

Description: Soft, white to yellowish powder, depending on the amount of iron oxide present; becomes semitransparent in oils

Used as:

(a) An extender in the manufacture of oil paint

(b) An ingredient (with white lead and linseed oil) in the manufacture of window putty

(c) A base in the manufacture of lakes

D.6 Chalk (precipitated chalk)

Materials: Artificially prepared calcium carbonate $(CaCO_3)$

Description: Very white, very fine homogeneous powder

Used as: An extender in the manufacture of oil paint

Advantages: Superior in whiteness and texture to the natural calcium carbonate

E. WAXES

Natural organic substances or crude oil distillates (petroleum waxes) are the common sources of waxes. The natural organic waxes are mixtures of a variety of components, but their melting points and color vary slightly. Petroleum waxes (paraffin and microcrystalline) have a

wider range of melting points, degrees of hardness and/or flexibility.

Waxes are added to paint to modify the pigment so that it becomes more suitable for oil painting. Waxes are also added to varnishes to impart hardness and/or to subdue the glossiness of a final varnish.

E.1 Beeswax

Material: Complex natural substances—a combination of hydrocarbons, alcohols, esters of acid, and acids

Source: The honeycomb created by the secretions of the worker honeybee (*Apis mellifica*)

Description: Brittle substance; natural yellow or refined to a bleached white; sold in cake form; melting point about 61–65°C (142–149°F)

Used as:

(a) A modifier and/or stabilizer for certain pigments, particularly in the home manufacture of oil paints, where the use of aluminum stearate is difficult to utilize properly (see Section K.3)

(b) A final coating on a painting (see Chapter 6)

(c) A modifier for a final varnish coating on a painting to create a mat or dull appearance (see Chapter 6)

E.2 Carnauba Wax

Material: Complex organic molecule

Source: The Brazilian palm tree (*Corypha cerifera*)—a natural

formation (deposit) on the **fronds**

Description: Yellowish, hard material; melting point 83–86°C (181–186°F)

Used as: A modifier of wax varnishes to harden and strengthen the resultant film

E.3 Microcrystalline Wax (e.g., Bareco Oil Company's Ultraflex ®)

Material: Petroleum crude oil distillate

Source: A product of the crude-oil distillation process with additional processes of crystallization and solvent extraction

Description: Flexible substance, less brittle than the usual paraffin waxes; white color; melting point 60–63°C (140–145°F)

Used as: An ingredient in wax/resin adhesive mixtures for the lining of paintings (see Chapter 7)

F. DRYING OILS

Drying oils change from a fluid layer to a dry hard film when exposed to air (the process of oxidation). This drying process is complex and not entirely understood by chemists. The fact that some oils dry and form a durable film makes them an ideal ingredient in the manufacture of oil paint and as a modifier for imparting various characteristics to the paint.

The manufacturing or oil-making process has a great effect on the properties or characteristics of the resulting oil. The

characteristics of each oil should be studied in relation to their proposed use.

F.1 Cold-pressed Linseed Oil

Material: Natural vegetable oil

Source: Extracted by pressing the seed of the flax plant (*Linum usitatissimum*)

Description: A pale yellow filtered oil

Used as:

(a) A medium for the grinding (manufacture) of oil paint

(b) An ingredient in painting and glazing mediums

Advantages:

(a) Dries with a tough, durable film

(b) Best oil to use in the manufacture of oil paint

Disadvantages:

(a) Yellows with age more than any other form of linseed oil except hot-pressed raw linseed oil

(b) Smaller amount of oil is extracted in process than with hot-pressing

F.2 Hot-pressed Raw Linseed Oil

Material: Natural vegetable oil

Source: Extracted from the seed of the flax plant by steam-heating the seed before extracting the oil

Description: Light brown, not clear

Used as:

(a) An ingredient in the manufacture of furniture polish and house paints

(b) Not used in artists' oil mediums

Advantage: Process yields more oil from the seed

Disadvantages:

(a) Forms inadequate paint films

(b) Poor dryer

F.3 Hot-pressed Refined Linseed Oil

Material: Natural vegetable oil

Source: Hot-pressed linseed oil that is refined chemically and bleached

Description: Pale yellow color resembling cold-pressed linseed oil

Used as:

(a) A grinding oil for commercial manufacture of oil paint

(b) An ingredient for commercial preparation of painting mediums, emulsions, etc.

Advantages:

(a) A finer, more suitable oil than hot-pressed raw linseed oil for the commercial manufacture of artists' materials

(b) Comes closest to sharing the advantages of cold-pressed linseed oil

(c) More readily available than cold-pressed linseed oil

F.4 Sun-thickened Linseed Oil

Material: Natural oxidized vegetable oil

Source: Cold, hot-pressed, or refined linseed oil that has been **emulsified** in water and exposed to the sun and air to thicken, after which the water is removed

Description: Thick, viscous, very pale honeylike liquid

Used as:

 (a) An ingredient in painting mediums and varnish mixtures

 (b) A **catalyst** to accelerate the drying of a painting medium

Advantages:

 (a) Dries more rapidly than cold-pressed or refined linseed oil

 (b) Dries with a gloss

F.5 Stand Linseed Oil

Material: Natural **polymerized** vegetable oil

Source: Cold, hot-pressed, or refined linseed oil that has been heated (about 300°C) for several hours in the absence of air

Description: A very thick, pale, slow-drying oil

Used as: An ingredient in painting mediums

Advantages:

 (a) Yellows least of all forms of linseed oil

 (b) Produces a tough film

 (c) When used in a painting medium, it dries with a smooth, glossy film

F.6 Poppy Seed Oil

Material: Natural vegetable oil

Source: Hot- or cold-pressed from the seed of the opium poppy (*Papaver somniferum*) plant

Description: Very pale yellow color

Used as: A grinding oil used by some commercial manufacturers, especially for grinding whites and light color pigments (because of its own light color)

F.7 Safflower Oil

Material: Natural vegetable oil

Source: Pressed from the seed of the safflower plant (*Carthamus tinctorius*)

Description: Pale yellowish oil

Used as: A grinding oil in the commercial manufacture of oil paint

Advantages:

 (a) Almost nonyellowing

 (b) Forms good strong films

Disadvantages: Not much research has been conducted on its use in artists' oil paints, although the oil is currently used by Permanent Pigments for their Everwhite[tm] paint because the oil does not yellow very much

F.8 Walnut Oil

Material: Natural vegetable oil

Source: Expressed from the nut of the walnut tree (*Fuglans regia*)

Description: Pale yellow-colored oil

Used as: An ingredient in painting mediums

Advantages:

 (a) Less tendency to crack than linseed oil

 (b) Yellows less than linseed oil

Disadvantages:

 (a) Dries very slowly (slower than linseed, faster than poppy seed)

 (b) Tends to become rancid in storage, which has precluded its use in the commercial manufacture of oil paints

G. VARNISH RESINS

Natural resins are products of certain trees, while synthetic resins are constantly being developed by industry; both serve a function for today's artist. Natural resins have traditionally been the main ingredient in the preparation of varnish, which can best be described as a resin in solution with a volatile medium such as turpentine, alcohol, or mineral spirits.

A *spirit varnish* is commonly understood to mean a simple varnish of resin dissolved in a volatile solution, although it might more accurately describe a resin dissolved in alcohol.

An *oil-varnish* is a resin that has been liquified (melted) by heating (when it is called **"rim resin"**) and then combined with a drying oil. Varnish is used as an ingredient in painting mediums and/or as a separate film layer. As an ingredient in painting mediums, it is used during the painting process to alter the manipulative quality, as well as the appearance of the dried paint film, usually imparting glossiness. When employed as a separate film layer, the varnish can be used as a final coating on the painting (final varnish) to protect and seal the paint layers, or it can be used to separate or isolate (isolating varnish) two or more paint layers.

A diluted varnish (retouch varnish) can be used during the painting process to give an appearance of wetness to sections of the painting that have dried with a dull or mat finish, so that the dullness does not interfere with the artists' aesthetic judgment. Retouch varnish is not a permanent varnish film.

Note: *It is important to understand that all natural resins used to make varnish become brittle and yellow with age.*

G.1 Copal Resin

Material: Complex organic compounds containing oxygen and resin acids

Source: Fossilized resin from dead trees and resin from a variety of living trees

Description: Clear, amberlike lumps; as a varnish exhibits a great variety of film hardness from very hard to soft, depending on the location and type of tree from which it is obtained

Used as:

(a) An ingredient in making oil-varnish

(b) An ingredient in making oil painting mediums

(c) A final picture varnish

Advantages: Very glossy and very hard film

Disadvantages:

(a) Darkens, is subject to cracking, and not easily redissolved — therefore, *not recommended* as a final varnish on oil paintings, since easy removal is one of the prerequisites for a final varnish

(b) Expensive and difficult to obtain in today's art supply market

G.2 Dammar (or Damar) Resin

Material: Composed of dammarolic acid and resins

Source: The Dammar fir of the Dipterocarpaceae family of

trees found in southern Asia, particularly Malaya and Sumatra; obtained by "tapping" the tree

Description: Best-quality lumps are of light straw color; lumps vary in size (1½ inches and smaller) and grade, the finest being the most clear and colorless

Used as: An ingredient in painting mediums, final varnish, and retouch varnish

Advantages:

(a) Does not darken or yellow as rapidly as other natural resins

(b) Easily dissolved to make varnish

(c) Has high gloss

Disadvantages:

(a) Has a soft film (softer than that of copal resin), although harder than those of linseed oil or mastic resin

(b) Does not dissolve in mineral spirits (could be considered an advantage)

G.3 Mastic Resin

Material: Complex organic compounds

Source: The bark of the Pistachio (*Pistacia lentiscus*) tree found in Mediterranean countries

Description: Small round "tears" or balls the size of a pea (approx. ¼ inch); yellowish color with a distinctive aromatic odor

Advantages:

(a) Perhaps more easily manipulated than dammar resin

(b) Light colored

(c) Very glossy

Disadvantages:

(a) Perhaps a greater tendency to **"bloom"** — produce a cloudy, blue-white surface effect believed to be caused by the presence of moisture in the varnish or by an inherent defect in the resin

(b) Soft film structure

(c) Does not dissolve in mineral spirits (possibly an advantage)

Note: *There is almost universal disagreement among researchers on the best resin for painting mediums or final picture varnish. Some state that copal resin should never be used as an ingredient in a painting medium because of its tendency to darken with age, while others recommend only copal resin for a painting medium because of its harder film. Others state that dammar "blooms" more than mastic, although most say just the opposite. Many claim that all natural resins are doomed to failure because they darken (yellow) and become brittle with age, and that the only answer is to be found in a synthetic resin.*

Synthetic resins have proven superior as final picture varnishes, but very little scientific evidence is available on the use of synthetic resins in oil mediums.

Recommendation: *Use dammar resin for painting mediums and a synthetic resin for a final varnish.*

G.4 Acryloid® B-72 (Rohm and Haas)

Material: Polymers of acrylic and methacrylic **esters**

Source: Synthetic

Description: Available in granules or a clear and colorless 50-per-

cent solid resin solution with toluol; soluble in toluol, a volatile coal-tar solvent

Used as: A final picture varnish

Advantages:

(a) Remains clear

(b) Flexible

(c) Durable

Disadvantages:

(a) Does not mix with drying oils — therefore, cannot be used as a painting medium

(b) When used as a final varnish, the toluol may affect underlying paint structure

Note: *The Weber Company's Univar ® in liquid or aerosol form seems to be based on this resin, as does Krylon's Crystal Clear ® no. 1303.*

G.5 Acryloid ® B-67 MT (Rohm and Haas)

Material: Polymers of acrylic and methacrylic esters

Source: Synthetic

Description: Available in granules or a clear and colorless 45-percent solid resin solution with mineral thinner; soluble in mineral spirits

Used as:

(a) A final picture varnish

(b) Possibly a paint medium when mixed with linseed oil and mineral spirits

Advantages:

(a) Mixes with drying oils

(b) Soluble in mineral spirits

(c) Remains clear and flexible

Disadvantage: Pending further test results, usefulness as a painting medium with linseed oil and mineral spirits remains unclear

H. SOLVENTS AND DILUENTS

A solvent dissolves solid substances (like lump resin) into a solution. **Diluents** "thin" (dilute) solutions, so they may be more suitable or usable in painting mediums or varnishes.

Volatile fluids can be both solvents and diluents, as explained by R.J. Gettens in *Painting Materials — A Short Encyclopedia* (New York: Dover, 1966), p. 192:

Whether or not a completely volatile fluid is a diluent or a solvent depends entirely on its relation to a particular solid. If the fluid is capable of dispersing all or part of that solid and holding it as so much suspended matter, then that fluid is a solvent for that solid. If it can not do this but is in some degree miscible with a solution formed by another fluid, it is a diluent. Turpentine, for example, is a solvent for mastic resin but is only a diluent to a small extent for solutions of certain synthetic resins.

The following are the seven most common solvent/diluents used in oil painting:

H.1 Turpentine (Pure Gum Spirit Turpentine)

Source: Distilled from the sap of pine trees; residue of the distillation process called **rosin** or **colophony**

Description: Clear with only a hint of residue (rosin) left upon drying; characteristic aromatic odor

Used as:

(a) An ingredient in resin varnishes

(b) An ingredient in painting mediums

(c) A diluent for oil paint

Advantages:

(a) Low fire risk

(b) Excellent solvent for resins

(c) Excellent diluent for painting mediums

(d) Evaporates completely and at a reasonable rate, allowing time for paint manipulation

Disadvantages:

(a) Slight possibility of local skin reaction in some users

(b) Vapors in a closed, unventilated room can be a health hazard

(c) Tends to oxidize and thicken after long storage

H.2 Mineral Spirits (White Spirits, Varsol ® Humble Oil Co., odorless paint thinner)

Source: Petroleum by-product

Description: White, clear, odorless

Used as:

(a) A cleaner for tools and brushes

(b) An ingredient in (synthetic) final picture varnishes

(c) Diluent for oil paints

Advantages:

(a) Leaves no residue when drying

(b) Evaporates at about the same rate (slightly slower) as turpentine

(c) Does not deteriorate or change chemically in storage

(d) Nontoxic, nonallergenic

Disadvantages:

(a) Does not dissolve dammar and mastic resin lumps

(b) Does not dilute dammar varnish mediums

(c) (Slight) potential fire hazard

(d) Has slightly less solvent effect than turpentine on dried paint films (an advantage in some instances)

H.3 Benzine (V.M. and P. [Varnish makers' and Painters'] Naphtha)

Source: Petroleum distillate

Description: Clear, pungent odor

Used as:

(a) A solvent for the removal of surface accretion on a painting (see Chapter 7)

(b) A solvent for the removal of resinous varnishes (see Chapter 7)

Advantages/Disadvantages: Has a stronger solvent action on resinous varnishes than mineral spirits or Varsol, but weaker than xylene or toluene. Has a **flash point** of less than 60°F.

H.4 Xylene (Xylol)

Source: A coal industry by-product

Description: Clear, distinctive odor

Used as: A solvent for the removal of resinous varnishes (see Chapter 7)

Advantages/Disadvantages: Has a stronger solvent action on resinous varnishes than mineral spirits, Varsol or benzine. Has a flash point of 80°F.

H.5 Toluene (Toluol)

Source: A coal industry by-product through coal-tar distillation

Description: White, clear, some odor

Used as:

(a) A solvent for synthetic resins

(b) A solvent for the removal of resinous varnishes (see Chapter 7)

(c) A solvent for the removal of surface accretion on a painting (see Chapter 7)

Advantages/Disadvantages: Has a stronger solvent action on resinous film than Varsol, benzine, and xylene (xylol). Has a relatively low (45°F), flash point

H.6 Isopropyl Alcohol

Source: A synthetic alcohol

Description: Clear, some odor

Used as: A solvent for the removal of resinous varnishes (see Chapter 7)

Advantages/Disadvantages: Has a stronger solvent action on resinous varnishes than mineral spirits, Varsol, benzine, xylene, or toluene. Has a flash point of 59°F.

H.7 Acetone

Source: By-product of molasses or corn mash fermentation or made synthetically.

Description: Clear, strong sweet odor.

Used as: A solvent for the removal of resinous varnishes (see Chapter 7).

Advantages/Disadvantages: Has a stronger solvent action on resinous varnishes than mineral spirits, Varsol, benzine, xylene, toluene, or isopropyl alcohol. Has a flash point of 15°F.

I. BALSAMS (OLEORESINS)

Balsams are the extruded resins of coniferous trees. The two most common ones are Venice turpentine and Strasbourg turpentine.

I.1 Venice Turpentine

Source: Extruded from deep taps to the heart of the larch tree (*Larix decidua*)

Description: Viscous, sticky, resinous, non-film-forming fluid

Used as: An ingredient in painting mediums to impart a glossiness to the final film

Advantages:

(a) Used in small amounts with oil mediums adds body and smoothness

(b) Does not yellow excessively

Disadvantage: Used excessively, it can prolong drying of oil paint

I.2 Strasbourg Turpentine

Source: The bark of the silver fir tree (*Abies pectinata*)

Used as: An ingredient in painting mediums

Description: Similar to Venice turpentine

Advantages: Like Venice turpentine, enhances the elasticity and durability of drying oils

Disadvantage: More expensive than Venice turpentine

J. DRIERS (SICCATIVES)

Driers (siccatives) are metallic salts in solution that accelerate the drying and oxidation of paint films. The most common ones are cobalt linoleate, cobalt naphthenate, and manganese.

J.1 Cobalt Linoleate

Material: Salts of cobalt mixed with linseed oil

Source: Salts of cobalt cooked in linseed oil

Used as: An addition to paint and painting mediums, to speed up the drying of paint films; to be used very sparingly—less than 1 percent added to a painting medium (one or two drops per tablespoon of paint)

Advantage: Speeds drying of thin paint films (to between 8 and 10 hours)

Disadvantages:
(a) Subject to yellowing and darkening with age
(b) Used to excess, creates a sticky gummy paint
(c) Does not work as effectively on impasto or thick paint

J.2 Cobalt Naphthenate

Material: Salts of cobalt mixed with naphtha

Source: Salts of cobalt cooked in naphtha

Used as: Same as cobalt linoleate (above)

Advantages/Disadvantages: A more recent industrial product with relatively the same advantages and disadvantages as cobalt linoleate

J.3 Manganese

Material: Manganese oxide and linseed oil

Source: Manganese oxide cooked in linseed oil

Used as: Same as cobalt linoleate (above)

Advantages: Speeds drying of thin paint

Disadvantages: Can cause excessive darkening and cracking

Recommendation: Cobalt linoleate and cobalt naphthenate are the best choices for artists' use because they do not darken as severely as manganese.

K. STUDIO MANUFACTURE OF OIL PAINTS

Making your own paint from powdered pigments and linseed oil can be a rewarding experience. It guarantees the quality of the ingredients, although they may be only slightly less expensive than commercially prepared oil paint. The process is not particularly difficult, since most pigments grind quite easily, but there are some pigments that require special attention and additives. Also, it is a process in which more time may be spent cleaning the tools and equipment than grinding the pigment.

Commercial paint-making techniques and equipment provide a very smooth, evenly dispersed pigmentation and uniformly ground product. Because the uniformity of the hand-ground product de-

pends heavily on the skill of the person doing the hand grinding, the quality of the paint may vary greatly.

K.1 Tools

(a) A glass muller with a grinding surface 3 to 4 inches in diameter (such as the one made by Fezandie and Sperrle)
(b) An approximately 20 x 24-inch ground or frosted glass or white marble work surface
(c) A stiff 4-to-6-inch palette knife and/or spatula
(d) Small heavyweight opaque white glass jars (pharmaceutical ointment jars)
(e) A 3-inch-wide wallpaper-type scraper
(f) A tablespoon
(g) A beaker graduated in ounces

K.2 Materials

(a) Artists' quality dry pigments (Fezandie and Sperrle)
(b) Cold-pressed linseed oil (Winsor & Newton)
(c) Pure gum turpentine
(d) White beeswax (Fezandie and Sperrle)

K.3 Technique and Procedure

If ground or frosted glass is unavailable, a new glass surface can be adapted by grinding it with **carborundum** grit; a new muller should be similarly prepared. This will provide a tooth on both the muller and glass surface, so that the paint will be properly ground.

STEP 1. Mix the carborundum #40 grit with a little water to form a paste and grind with the muller over the glass surface until the surface is rough and appears frosted.

STEP 2. Thoroughly rinse the muller and glass under running water, scrubbing them with a stiff brush to remove all traces of the carborundum.

When everything is clean and dry, the paint making process may begin.

STEP 1. Place approximately a 2- to 3-ounce (by volume) mound of dry pigment in the center of the grinding area and begin to add linseed oil a little at a time. Using a palette knife or spatula, work the pigment and linseed oil into a stiff paste and place it to one side. Start another mound of pigment, add oil, and so on: repeat this process until you have made the desired quantity of the first color (Figure 4–1).

STEP 2. Gather all the paste mounds and work them into one large mound. Place this mound to one side of the grinding surface.

STEP 3. To begin the actual grinding process, place a tablespoon of pigment paste into the center of the grinding area.

STEP 4. With the muller, grind the paste using rotating motions working from the center to the edges (Figure 4–2). Continually scrape the paste from the sides of the muller with the scraper and gather the paste on the grinding surface into a mound. Continue grinding until there is no gritty sound and no signs of granular pigment. The paste should now begin to look like commercial paint—smooth, glossy, and uniform in texture. If the mass is too liquid, add more pigment to the paste, rework, and begin again. Add more oil if the paste is too

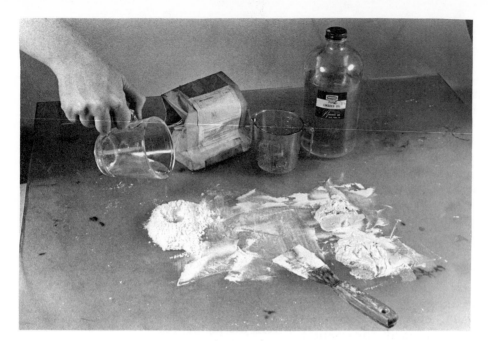

Figure 4–1

Figure 4–2

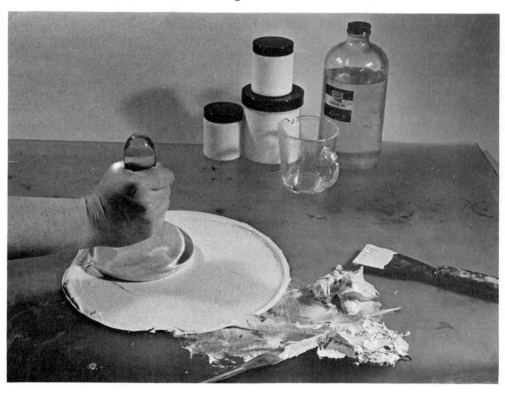

dry. Make a quick spot check for uniformity with the wallpaper scraper by scraping a small amount across a white piece of smooth cardboard or paper. Inspect for clumps of pigment undispersed in the oil.

STEP 5. When the grinding is complete, move this batch of paint to one side and repeat the process with additional paste.

STEP 6. When all the paste has been ground into paint, gather together all of the small batches of paint and grind them into one homogeneous mass. The paint should now have all the characteristics of commercially ground paint.

Certain colors are known to have characteristics that make grinding more difficult, including: difficulty in accepting the oil (hard to "wet"), brittleness when mixed alone with linseed oil, settling out (heavy pigments), hardening in storage, "stringy" when ground alone with linseed oil, a granular texture, and other undesirable characteristics. Some of these problem colors are Titanium white, Zinc white, Vermilion, Indian red, Venetian red, Mars orange, Mars yellow, Naples yellow, Zinc yellow, Viridian green (especially difficult) Chromium oxide green, Ultramarine blue, Prussian blue, Cerulean blue, and Manganese blue.

Problem colors can be more easily ground by grinding with a mixture of ½ ounce (by weight) of beeswax and 16 ounces (by volume) of linseed oil. The mixture can be made by slowly heating 4 ounces of linseed oil in a metal container, then adding the ½ ounce of beeswax and stirring. Heat until the beeswax is melted and thoroughly mixed. Remove the container from the heat and slowly add the remaining 12 ounces of linseed, continually stirring until the beeswax is thoroughly dispersed. Use this mixture in the grinding process as you would the pure linseed oil.

Finally, transfer the finished paint into the glass jars for storage and tightly cap to exclude air. There are advantages to using jars instead of tubes to store the paint: not only are tubes less readily available as they used to be, but they are more difficult to pack; also, should the paint settle out or separate after being stored in the jar, it can easily be removed and reground.

The production of several colors may be produced more efficently if a group of artists or art students get together and each person grinds a single color in quantity. The group can then exchange paints to achieve a wide selection of colors.

L. STUDIO MANUFACTURE OF DAMMAR VARNISH

Dammar varnish can be made easily and economically in the studio. The best grade, no. 1 Singapore dammar crystals, can be obtained through various supply houses, including Utrecht Linens. Dissolved in pure gum turpentine, the crystals become dammar varnish. The procedure is relatively simple:

STEP 1. Place 10 ounces of the dammar crystals in a cheesecloth bag or a ladies' nylon stocking. Tie the top of the bag with string, leaving a length of string free.

STEP 2. Add 1 pint of gum turpentine to a large jar (capacity greater than 1 pint) with a metal cover.

STEP 3. Punch a hole in the cover (while removed from the jar). Thread the

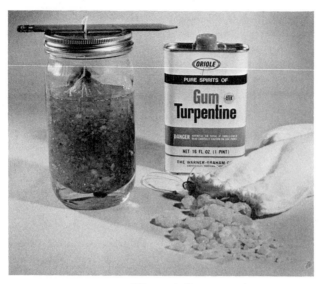

Figure 4–3

bag string through the hole (from inside to outside) and tie the string to a pencil to hold it from slipping through.

STEP 4. Lower the bag of dammar crystals into the gum turpentine, screw on the jar top, and adjust the string so that the bag is completely suspended in the gum turpentine and free from any contact with bottom of the jar (Figure 4–3).

STEP 5. In 24 to 36 hours, the crystals will be dissolved, forming dammar varnish. Remove and dispose of the bag, which will contain various impurities (dirt, bark, etc.).

STEP 6. Allow any impurities that remain in the solution to settle to the bottom of the jar, and pour the dammar varnish through cheesecloth into another jar and cap tightly.

Note: *10 oz. by weight of dammar crystals to 1 pint of gum turpentine is equivalent to the commercial standard of 5 pounds by weight of crystals to 1 gallon of gum turpentine (known as a 5 pound cut varnish or a standard solution).*

Chapter Five

TOOLS AND EQUIPMENT

A. OIL PAINTING BRUSHES

1. The Manufacturing Process

2. Shapes and Styles of Brushes
 a. *Bristle Brushes*
 1) ROUNDS
 2) FLATS
 3) BRIGHTS
 4) FILBERTS
 b. *Red Sable Brushes*
 c. *Speciality Shapes and Styles*
 1) FAN BLENDER
 2) BADGER BLENDER
 3) VARNISH BRUSHES

3. Selection of Brushes

4. Care of Brushes
 a. *Cleaning*
 1) CLEANING WHILE PAINTING
 2) OCCASIONAL CLEANING
 b. *Storage*

B. PAINTING KNIVES AND PALETTE KNIVES
 1. Painting Knives
 2. Palette Knives

C. PALETTES
 1. Wood Palettes
 2. Marble Palettes
 3. Glass Palettes
 4. Metal Palettes
 5. Formica® Palettes
 6. Paper Palettes
 7. Palettes of Miscellaneous Materials
 8. Notes on Paint Storage

D. EASELS
 1. Simple Wood Easel
 2. Heavy-duty Wood Easel
 3. Radial Easel
 4. Metal Easel
 5. Home-built Easel Devices

Chapter Five

TOOLS AND EQUIPMENT

This chapter is concerned with the basic tools and equipment of oil painting. Most of the items included in this chapter are available in well-stocked art supply stores.

A. OIL PAINTING BRUSHES

A.1 The Manufacturing Process

Brush tips for oil painting are made from a variety of hairs and bristles including those of the red sable and black sable, ox hair, fitch (Russian fitch or skunk) hairs, badger hair, and hog or boar bristles. Nylon bristle brushes designed for use with acrylic paints are not suitable for oil painting. The best brushes for oil painting have tips made of bleached white hog's bristles or red sable hair. The natural hog bristle is unique in that each bristle end is naturally split or branched. This multiple tip is called a **flag** (Figure 5–1). This flag tip holds and deposits paint in a smooth and continuous stroke. This characteristic, along with the basic resiliency of the bristle, makes this tip a traditional favorite.

Oil painting brushes with tips made of red sable (the tail hairs of the weasellike red tartar marten) have a much finer, naturally pointed hair ending. The red sable brush is best used with paint of a reduced viscosity for fine or detailed art

Figure 5–1

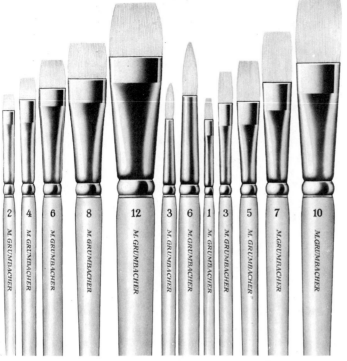

Figure 5–2

Figure 5–3

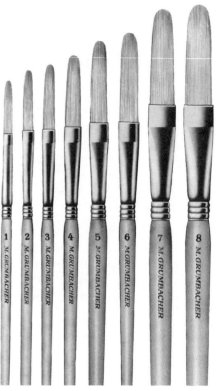

Figure 5–4

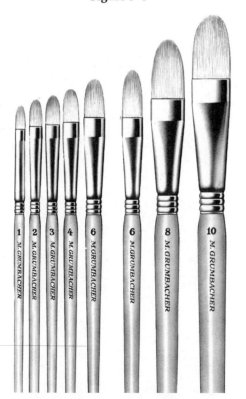

work, especially where an especially smooth and accurate stroke is required. Bristle-tipped brushes are useful in manipulating thicker paint in broader strokes.

The manufacturing process of all oil painting brushes is just about the same regardless of the type of hair or bristle. The most important step after a careful selection, processing, and grouping of the hairs or bristles is the formation of the brush tip. In order to form the shapes of the various styles of tips, the hairs or bristles are packed into metal cups or molds natural end down. The root ends are then bound and clipped to a uniform length. A seamless metal tube called a

ferrule is slipped over the root ends, and a thermosetting resin is poured into the open end of the ferrule so that the hairs or bristles adhere to one another. After this heat-setting process, a wood handle is inserted into each ferrule. The ferrule is then crimped around the handle, completing the process.

A.2 Shapes and Styles of Brushes

A.2(a) Bristle Brushes

Bristle brushes are available in four basic shapes: round, flat, bright, and filbert. Most of these shapes are available in sizes that range from small (no. 0 or 1) to large (no. 12) and extralarge (nos. 14–24).

A.2(a.1) ROUNDS. The round brush was the shape most commonly used from the times of the old masters through the nineteenth century. Round brushes have a simple tubular shape with a semiblunt point which allows for a great variety of manipulations. Rounds are available in sizes 1–12 and are pictured in the center of Figure 5–2.

A.2(a.2) FLATS have a rectangular shape with the bristles ending in a straight line. They are set in a specially formed ferrule which maintains the flat shape of the tip. Flats are available in sizes 1–12 and are pictured on the right side of Figure 5–2.

A.2(a.3) BRIGHTS have the same bristle shape and construction as flats; the only difference between the two is that the bright's bristle length is shorter. Brights are available in sizes 1–12 and are pictured on the left side of Figure 5–2.

A.2(a.4) FILBERTS, when viewed in cross-section, are unique in that they are set in an oval crimped ferrule. Filberts have a thicker collection of bristles than do either flats or brights, a characteristic enabling the filbert to hold more paint than those styles. The most distinguishing feature of the filbert is its curved or arch-shaped tip. The shape of the tip is formed by placing naturally curved bristles on the outer edges of the tip so that they curve inward, which helps counteract the tendency of the tip to splay outward with repeated use. Filberts are available in three bristle lengths: short and long in sizes 1–12 (Figure 5–3) and extralong in sizes 1–8 (Figure 5–4).

A.2(b) Sable Brushes

Sable brushes for oil painting have approximately the same shape designations as bristle brushes, with two exceptions: the sable *long* looks like a bristle *flat* and the sable *flat* looks more like a bristle *round* with a square tip. The brights, rounds, and filberts are the same shape in both styles. Sable brushes are available in a wide range of sizes from small (no. 00) to large (no. 20). Figure 5–5 shows (left to right) brights, rounds, and longs. See Figure 5–6 for sable filberts.

A.2(c) Specialty Shapes and Styles

A.2(c.1) FAN BLENDER. This brush has a distinct thin-edge fan shape and is made from either hog's bristle or red sable sparsely set in a crimped ferrule. Its function is to blend or defuse the line between two adjacent colors or graduate a **tint** or **shade**. It is always used to manip-

ulate paint that is fluid and already applied to the canvas. Stroking the dry fan blender gently across the paint with the handle almost parallel to the canvas surface usually achieves good results. Red sable blenders are available in sizes 1 through 6. Bristle fan blenders are available in sizes 3 through 6. The fan blender is pictured on the left in Figure 5–7.

A.2(c.2) Badger blender. Made from badger bristles this brush is traditionally set in a ferrule made of natural **quill** (the base of a large feather) bound or held in place with wire. The shape is round with bristles of equal length. Its function is approximately the same as that of the fan blender, but the technique of blending with it is different. The badger brush, used dry and clean, is held perpendicular to the canvas and pounced (lightly jabbed) into the wet paint on the canvas surface. This action breaks down the division between two adjacent colors and creates a graduated effect. In the pouncing technique, a metal ferrule would tend to cut the bristles at their base; thus the quill with its less sharp edge is preferred as a material for the ferrule. Badger brushes are available in sizes 1–6. The badger blender is pictured on the right in Figure 5–7.

A.2(c.3) Varnish brushes. Brushes used for the application of a final varnish to a painting (see Chapter 6 for technique) vary according to different artists' judgments. In general, however, varnish brushes are made from ox hair or ox hair/bristle combinations. They are chisel-shaped with a straight edge and set in round or flat handles. The size number of a varnish brush usually indicates its width in inches; thus size nos. 1 and 3 are 1 and 3 inches wide, respectively. Figure 5–8 shows full and side views of varnish brushes.

A.3 Selection of Brushes

There is almost universal agreement among artists that the brush is the most important tool at his disposal. Although there are cheap brushes on the market made from various combinations of hairs and bristles, they almost always are unsatisfactory in practical use. They lose their shape, lack resiliency, their bristles fall out, and their handles break.

In selecting a quality brush you should look for one whose tip is composed of natural hair or bristle endings. Remember, the bristle tip will have the natural split or flag end, and the sable tip will have a naturally pointed end. Any brush with a machine-cut tip is easily identified by cut blunt end and should be rejected. Better brushes also have seamless ferrules and painted or clear-**lacquered** handles.

Most manufacturers apply a light coating of a **gum** solution to the finished tip. This defines the shape more clearly and protects the tip during shipment. Because this gum solution is rather weak, using the brush under normal conditions will remove the gum.

Remember, quality brushes are essential. They perform better and last longer, thereby offsetting any initial extra expense.

A.4 Care of Brushes

A.4(a) Cleaning

A.4(a.1) Cleaning while painting. During the painting process, a metal container of mineral spirits is used for

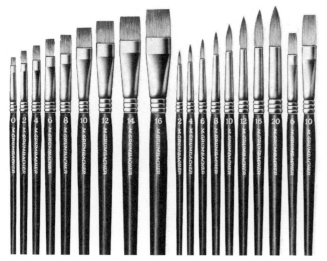

Figure 5–5

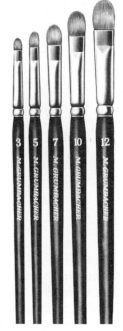

Figure 5–6

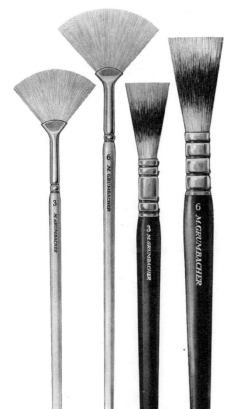

Figure 5–7

Figure 5–8

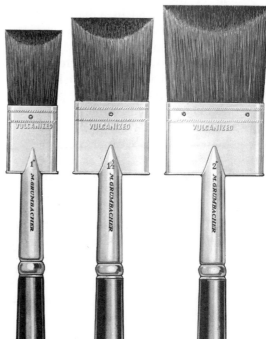

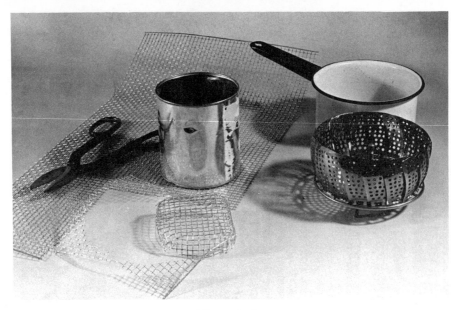

Figure 5–9

cleaning brushes. This container can be made more efficient by inserting wire screening to create a false bottom. The mesh of the wire should be small enough to prevent the smallest brush from passing through it. The wire must also be stiff enough so that its corners may be bent down to form a raised platform on the bottom of the metal container. A vegetable steamer placed in a pan will also serve well as a brush washer (see Figure 5–9). The mineral spirits are poured to a level above the wire screen. When cleaning is necessary, the brush is rubbed across the screen, the heavy pigment settles below, and the mineral spirits stay clean longer.

A commercial brush cleaner with a cover-and-screen device is available (Figure 5–10) if you do not wish to make your own brush-cleaning device.

A.4(a.2) Occasional cleaning with soap and water is necessary to prevent a heavy buildup of paint at the base of the brush.

To begin the cleaning process, wipe the brush on newspaper or a rag to remove the excess paint, and then wash it several times in clean mineral spirits (preferred over turpentine for its lower cost and nontoxicity). Holding the brush under running warm (*not hot*) water, al-

Figure 5–10

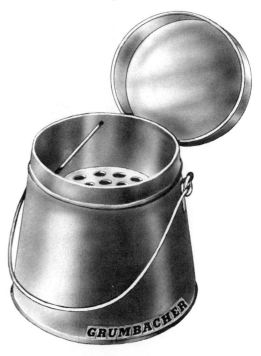

ternately rinse it and lather it on a cake of yellow laundry soap or a soap containing pumice (for example, Lava ®). Continue this lathering/rinsing process until the soapsuds show no trace of paint color. The brush should then be rinsed thoroughly and shaped by drawing it across the palm of the hand. Lastly, place the brush handle down in an open container until dry.

A.4(b) Storage

Brushes are always to be kept in open containers, handles down, except for

B. PAINTING KNIVES AND PALETTE KNIVES

B.1 Painting Knives

Painting knives may be used for either applying paint directly to the canvas or mixing the paint on the palette. Painting knives are available in a great variety of blade shapes and sizes. The various trowel shapes are formed directly from the bent, round **shank** and set in a wood handle. The shank shape allows paint manipulation without getting one's knuckles in the paint. Painting knives of

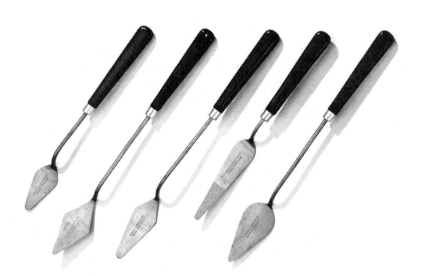

Figure 5–11

prolonged storage when they may be wrapped in paper or shaped and dipped in a dilute solution of gum arabic and placed in a drawer or box. If you are storing sable brushes, add mothballs to the container or drawer to prevent their destruction by moths.

poor quality in which the shaped blades are welded to the shank should be avoided. The variety of available sizes and shapes provides a wide range of blade flexibility and resiliency (Figure 5–11). Three or four mixed sizes and shapes should suit the average painter's needs—

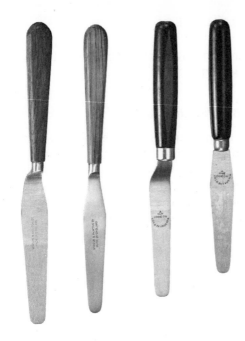

Figure 5–12

unless he or she chooses to paint exclusively with painting knives, in which case a greater selection may be necessary.

B.2 Palette Knives

Palette knives are used for mixing paint on the **palette**, scraping old paint from the palette, and manipulating the pigment and oil during the grinding of paint.

The characteristic shape of the palette knife is that of a spatula. Palette knives have long flat blades and are available in various sizes (Figure 5–12). Palette knives that will be primarily used for scraping a palette clean should have larger, stiffer blades, while palette knives used for color mixing should be resilient but more flexible. Again, a variety of two or three should be sufficient for average use.

C. PALETTES

A palette can be defined as a nonabsorbent surface on which to arrange and mix colors. Traditionally, palettes have been made of wood and held in the hand or on the arm while painting. Today's painter more frequently uses a larger palette set on a table or even the tabletop itself. The following list indicates some of the materials available for use as a palette:

C.1 Wood Palettes

Although thin wood palettes with a thumbhole are still available to the painter, they have several disadvantages for studio work. First, the standard color or tone of the wood is either light pine or dark brown. This may have been appropriate during the period when artists began their painting on a nonwhite ground, because colors mixed on such a palette would appear the same when applied to the canvas. Mixing colors on a brown surface, however, could result in many optical surprises when the paint is applied to the white or nearly white canvas surfaces used today. Therefore, most artists now choose to mix their colors on a white or nearly white surface. A second disadvantage is that most wood palettes are too small for the contemporary artist. And lastly, if the wood surface of the palette is not already prepared with a coat of shellac to reduce the absorbency of the wood, several applications of linseed oil will have to be applied and rubbed in and the excess wiped off.

C.2 Marble Palettes

A marble tabletop or slab of white marble makes an excellent palette and/or

surface for grinding paints. Its only drawback is its susceptibility to paint stains.

C.3 Glass Palettes

Auto window glass, tempered, reinforced glass, or plate glass probably makes the best palette for studio use. The sharp edges should be ground off or covered with adhesive tape to prevent injury. The underside may be painted white, or the glass merely placed on a sheet of white paper. Glass is durable, easy to clean, and not affected by any solvents or oils the artist may use.

C.4 Metal Palettes

Sheet aluminum tacked down to a tabletop can also serve as a palette, as can the harder-to-locate but equally suitable old white enameled tabletop. Tables with enameled metal tops may still be found in used furniture stores and thrift shops.

C.5 Formica® Palettes

A white **Formica** surface can be used as a palette, but it may be susceptible to staining by certain colors and solvents.

C.6 Paper Palettes

Pads of plastic-coated disposable paper palettes are readily available. Most are shaped like the traditional thumb-hole wood palette and therefore are useful for painting outdoors. Although they are available in sizes up to 12x16 inches, these are still relatively small and somewhat impractical for studio use. Their main advantage is that used sheets may be torn off and thrown away after each painting session. This saves some time in cleaning, although the advantage is minimal.

C.7 Palettes Made from Miscellaneous Materials

China and glazed pottery plates and cups, large clamshells, and small glass containers may be used as palettes and mixing vessels. However, items to be avoided include those that will be dissolved by turpentine and other paint solvents, such as styrofoam (hot-coffee) cups and wax-coated (cold-drink) cups.

C.8 Notes on Paint Storage

As a rule, paint that has begun the drying process through oxidation and chemical change loses some of its adhesive quality. On a day-to-day basis, this process may be delayed by covering the palette with clear plastic sandwich wrap. Although this somewhat retards the drying of the paint on the palette, the removal of the plastic wrap is a messy process involving some paint loss.

Masterson Enterprises manufactures a product called the Artist's Palette Seal®, which is a shallow, lidded plastic box that will accommodate a palette up to 12x16 inches. The lid fits tightly and effectively slows the drying rate of the oils.

Another storage method involves removing the paint from the palette, applying it to little slabs of glass, and placing these in jars of water; on the other hand, the whole glass or metal palette may be submerged in water. This method prevents a skin from being formed on the paint, but when the paint is ready to be reused the water must be shaken from

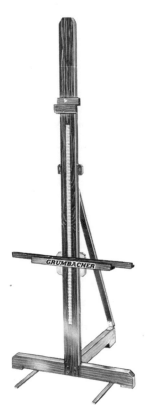

Figure 5–13

sion; others scrape the entire palette clean; and still others work on a continual buildup of paint. The photograph on the front cover illustrates four different approaches to color organization on a palette.

D. EASELS

The variety of commercial wood and metal easels available is extensive. But most of the collapsible tripod-type wood and aluminum easels, while acceptable for work outdoors with watercolors or a sketch pad, are too lightweight for studio oil painting. There are four types or styles of studio easels that are recommended; they are as follows:

Figure 5–14

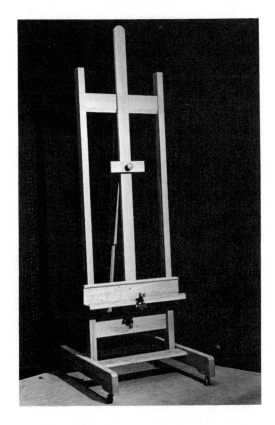

the glass and then allowed to evaporate before the painting process begins. Paint on the palette or in the tube may be safely frozen, thawed, and reused.

In student work, where permanence of the painting is not a prime factor, the skin which forms on a large glob of paint may be slit with a painting knife and softened with a solvent before being used.

One final word: the organization of colors on a painter's palette is as personal as his painting. Generally, the paints are arranged around the outer edge of the palette, leaving the center portion free for color mixing. Some painters scrape just the center clean after each work ses-

D.1 The Simple Wood Easel

The first easel is the simple folding (for flat storage) wood easel (Figure 5–13) that is probably the most commonly used easel today. It is constructed with the minimum basic features necessary in a studio easel: (a) a sturdy vertical support for the painting; (b) a base connected with adjustable metal plates and hinges held with screws; (c) a metal ratchet-type system for raising and lowering the crossbar on which the painting rests; (d) an overall height to accommodate at least a 60-inch-high painting. The manufacturer of the easel in Figure 5–13 is M. Grumbacher.

D.2 The Heavy-Duty Wood Easel

The second wood easel, typical of the large or heavy-duty studio easel types (Figure 5–14), can accommodate a painting up to 60 inches high. The easel in Figure 5–14, the Weber Company's Rembrandt Easel ®, is constructed of sturdy oak. Like the simple folding easel mentioned in Section D.1, it is completely adjustable to any forward or backward angle. It has a unique positive-action crank which permits easy raising and lowering of the support tray on which the painting is placed. This larger easel has triple vertical painting supports and a large cross-braced base with wheels.

D.3 The Radial Easel

The third recommended wood easel (Figure 5–15), the Dual Purpose Radial Easel ® #162 manufactured by Winsor & Newton, has a number of special features. It is made of heavy-duty high-quality beechwood with substantial

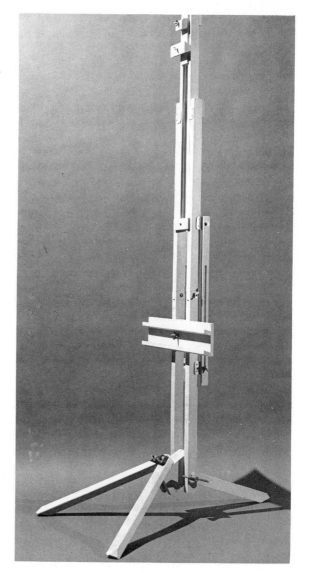

Figure 5–15

metal hand-operated adjusting screws and pins. Mounted on folding tripod legs, it can accommodate a 76-inch-high painting. One unique feature is that the vertical painting support is jointed so that a smaller painting may be accommodated using only the top half of the vertical support. This allows the support to be tilted back to a horizontal position

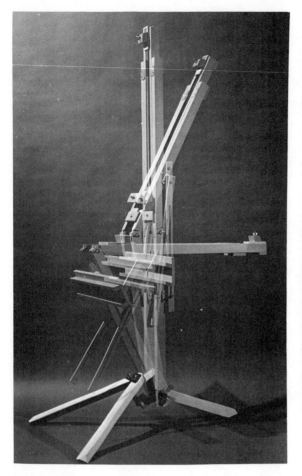

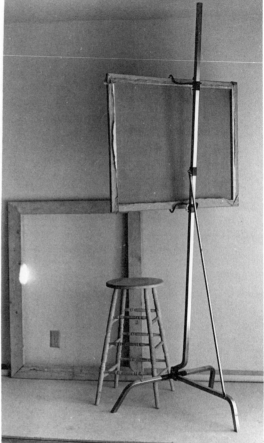

Figure 5–16

Figure 5–17

without affecting the working height of the easel (Figure 5–16). The easel may be used in this manner with paintings up to 26 inches high. This feature can be very useful when applying a final varnish or when working with very fluid paint.

D.4 The Metal Easel

The fourth easel (Figure 5–17) is an award-winning all-steel easel, the James Howard Company's Standard Easel®. Composed of a simple adjustable square steel vertical painting support mounted

on a three-leg base, it can accommodate a painting 80 inches high. Although it weighs less than any of the other easels mentioned, it feels more solid and substantial when in use. Because of its design and all-steel construction, it is very durable and easy to use. It is fully adjustable backward and forward and has positive clawlike grips (Figure 5–18) to hold the painting.

With the exception of the more expensive Weber's Rembrandt oakwood easel, all the easels described above are

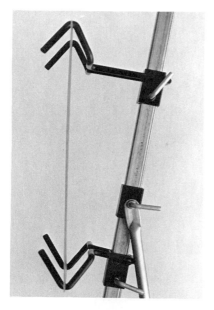

in the same price range. All four easels were selected on the basis of their superior construction, craftmanship, durability, and practicality.

D.5 Home-Built Easel Devices

Many painters with a designated space for a studio prefer to paint on prepared canvas that is unstretched. In such a case, the painter can proceed to paint without an easel by affixing the prepared canvas directly to a smooth permanent wall. If attaching the canvas directly to a wall is not possible or practical, an easel or painting surface of sorts can be made with one or two sheets of plywood set up side by side. The plywood, either free-

Figure 5–18 **Figure 5–19**

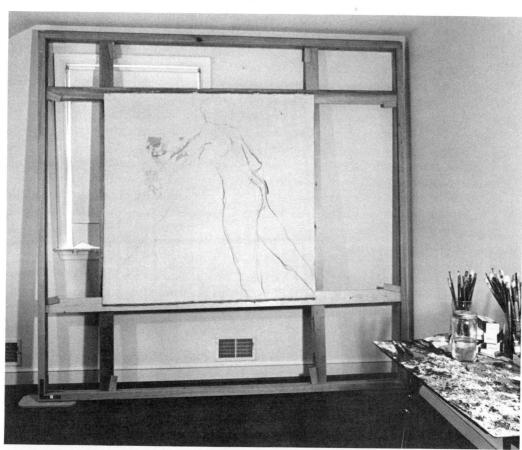

Figure 5-20

standing on a constructed frame or leaning against a wall, provides a surface on which to staple the canvas. If two 4x8-foot pieces are to be used, creating an 8x8-foot painting surface, the seam between the two sheets of plywood should be sealed with 2-inch-wide aluminum-colored tape ("gaffer's tape"), industrial duct tape, or rug pad tape.

If the painter prefers not to have a hard surface behind the unstretched canvas while working, he or she may wish to construct the following adjustable frame device for temporarily stretching the canvas semitaut. The concept is simple. The painter needs four 1x4-inch pine boards each 8 feet long (although the length of the boards depends on the studio space and the size canvas the painter prefers). Securing these four boards in a tic-tac-toe grid, the painter can then

staple a canvas to the surface of the boards that form the central square and proceed to paint. When finished, the work can be removed from the frame and later permanently stretched on an adjustable stretcher or strainer.

All that remains to construct such a system is a sturdy grooved frame to hold the four boards in a variety of positions. The frame could then be padded and leaned against an existing wall for the painting process. Figure 5-19 shows an 8x8-foot grooved red oak frame constructed to hold four 1x4-inch by 8-foot (approximate) adjustable crossbars. The groove in the frame is wide enough to allow the crossbars to slide freely. When the desired position is reached, the crossbars are held firm by inserting large oak wedges or shims (Figure 5-20).

76

TECHNIQUES OF PAINTING

A. **THE SKETCH**

B. **DIRECT PAINTING (ALLA PRIMA)**
 Formulas for general painting medium

C. **GLAZING AND SCUMBLING**
 1. Glazing
 Formulas for glaze painting medium
 2. Scumbling

D. **IMPASTO**

E. **MIXED MEDIA AND MATERIALS**

 1. Mixed Media
 2. Painting Over Old Oil Paintings

F. **COLLAGE**

G. **FINAL VARNISH**
 1. Natural Resin
 a. *Final Varnish*
 b. *Retouch Varnish*
 2. Synthetic Final Varnishes
 3. Beeswax
 4. Application of the Final Varnish

Chapter Six

TECHNIQUES OF PAINTING

The discussion on the various techniques of painting that follows is an attempt to give the art student some idea of the descriptive terminology used in the field, as well as some practical advice. It should not be construed to mean that what is described in this chapter is the only way or even the necessary way to paint. Since painting is an organic process where ideas and techniques change in reaction to either visual effect or aesthetic necessity, this chapter is merely a point of departure and it makes no pretense as to aesthetics or style of painting to be pursued.

This chapter is a guide to the wide range of technical choices available when using oil paint, including some techniques for painting thickly (**impasto**), or thinly (glazing), or with other textural effects (**mixed media**), and so forth. Techniques are secondary to the concept of the painting, but they take precedence when the rendition of an idea is frustrated by poor technical practice. The reader should extract from this chapter those formulas and techniques that in-

terest him or her and adopt them to his or her style.

A. THE SKETCH

If a sketch on paper (a broad delineation of areas or a detailed outline) is to be transferred from the paper to the canvas, the back of the paper can be covered with charcoal or powdered graphite and held against the canvas while traced. Or the sketch can be ruled off into a grid of 1-inch squares, the canvas ruled off into a grid of larger squares, and the sketch then reproduced on the canvas using the grids as a guide. The sketch can also be drawn directly on the canvas with vine charcoal, pencil, or oil paint thinned with turpentine. *CAUTION:* Excess thinning with turpentine causes oil paint to separate on the canvas, leaving fine little hairline cracks; this is to be avoided.

If charcoal was used in making the sketch directly on the canvas, it should be fixed by dusting the heavy excesses of

charcoal from the canvas with a cloth leaving only a latent image or by spraying with a fixitive like Krylon Crystal Clear. Do not use felt-tip pens or ballpoint pens because the inks in these products will bleed through subsequent layers of paint.

B. DIRECT PAINTING (ALLA PRIMA)

The traditional concept behind direct painting or **alla prima** is that the painting is finished in one "sitting" or session. The sketch is applied directly to the canvas with little or no medium added and the image delineated in broad color and tone areas, working with wet paint into wet paint (traditionally, lighter colors into darker) and leaving either all or only some of the colors applied visible in the finished work. The work of the twentieth-century abstract expressionist painter Franz Kline (1910–1962) is a typical example of direct painting (Figure 6–1).

In order to make the paint flow and brush more readily, an all-purpose medium or vehicle may be mixed with the paint. The formulas given below are for general painting use. They vary only slightly in their ingredients and proportions; the painter should experiment to find one that suits his approach. The reason for mixing several ingredients is

Figure 6–1

Courtesy of National Collection of Fine Arts, Smithsonian Institution

Figure 6-2

first, the resinous varnish (dammar) used alone dries with a brittle film. Also, while linseed or stand oil used alone dries with an oily, soft film, oil and dammar when used together compensate for one another's weaknesses. Finally, turpentine is added to make the thick, sticky mixture more fluid and brushable. All the formulas are measured by volume and use the standard 5 pound cut solution of dammar.

FORMULA 1

2 parts dammar

2 parts linseed oil

2 parts gum spirit turpentine

FORMULA 2

1 part dammar

2 parts linseed oil

6 parts gum spirit turpentine

FORMULA 3

1 part dammar

1 part linseed oil

5 parts gum spirit turpentine

If you wish to accelerate the drying time of any of the formulas, add 10 to 15 drops of cobalt linoleate drier. If the formula is too thick to work with, add a small amount of additional turpentine. For convenience, the formula may be mixed and stored in a soft plastic bottle with a narrow spout (available in 5-and-10-cent stores). To use the medium, squeeze one or two drops onto the paint and mix with a brush or painting knife (Figure 6-2).

81

C. GLAZING AND SCUMBLING

C.1 Glazing

The traditional form of glaze painting involves a complete *underpainting,* usually in monochrome (black and white and their mixtures) tempera paint, followed by thin *glazes* of transparent oil colors. Glaze painting has come to mean any painting built up in thin layers or veils of color over other, lighter opaque (body) colors. For example, the artist wishing to use the color orange would apply a quantity of yellow paint (opaque) on the canvas, *allow it to dry* to the touch, and apply a thin (transparent) layer of red paint *over* it. The yellow would now appear yellow-orange. After the red layer had dried, the artist would apply another layer of red—and so on, until the orange is the color desired. This orange color will have more depth and luminosity and will appear richer in color saturation than if the red and yellow had been mixed on the palette and then applied to the canvas. In summary, the process begins with the application of an underpainting of lighter colors, usually mixed with an opaque white (lead or titanium). When the underpainting is dry, paint that is mixed with a glaze formula (given below) is applied in thin layers. The glaze layer may be applied with a brush and after application may be rubbed in with the fingers or a cloth to thin the paint film further; or it can be almost entirely wiped off the surface and left to remain in the crevices of the underpaint and weave of the canvas. The work of the Hudson River school artist George Inness (1825–1894) seems to typify the glazed-burnished technique (Figure 6–3). Glaze layer after glaze layer can be built up in this manner. The naturally transparent colors (alizarin crimson,

Figure 6–3

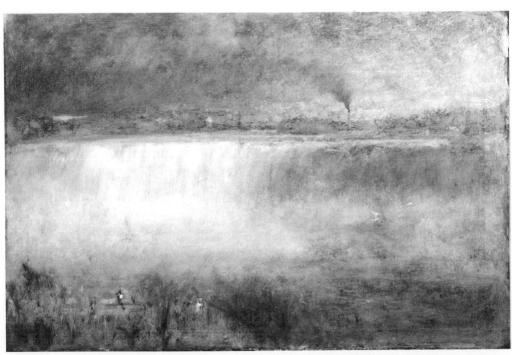

viridian green, phthalocyanine blue, and so on) are the best choices for glazing, but other colors can appear more transparent than usual when mixed with a glaze medium. Several glaze medium formulas are listed below:

FORMULA 1

1 part dammar

2 parts sun-thickened linseed oil

2 parts gum spirit turpentine

FORMULA 2

2 parts dammar

1 part linseed oil

2 parts gum spirit turpentine

8–10 drops of cobalt linoleate drier

FORMULA 3

7 parts dammar

4 parts stand oil

2 parts Venice turpentine

9 parts gum spirit turpentine

C.2 Scumbling

Another technique that may be employed in the process of glaze painting is called **scumbling**. After the painting develops from a lighter (opaque) underpaint to a painting covered with rich, darker (transparent) film layers, you may wish to introduce some lighter areas. This is usually done by scumbling over the dried glaze films with a *thin* opaque lighter color: opaque paint may be applied directly without a glaze medium and rubbed in with fingers or cloth or mixed with a glaze medium and applied in the usual manner. Rich effects of color contrast can be achieved if the scumbled layer partially covers the darker glaze layer, allowing the latter to show through the uncovered areas.

D. IMPASTO

One of the great characteristic advantages of oil paint is its ability to be used in very thin layers (glazing) or in thick layers (impasto). Impasto painting, exemplified by the work of Vincent van Gogh (1853–1890) (see Figure 6–4) and others, is a process that uses the paint without the addition of any medium; in a way, it is another form of direct painting. Using the paint without a medium (glaze or general) can be quite expensive. A studio-size (1x4-inch) tube will not cover much area. However, there are available commercially several gelatinous materials that extend the paint while maintaining its consistency and texture. Typical of these mediums are Winsor & Newton's Oleopasto® oil painting medium (oil-modified alkyd resin in **silica**), Utrecht Linen's Flex-Gel®, M. Grumbacher's Zec® and Gel® (Zec dries faster than Gel), and Weber Company's Res-n-Gel® (colloidal synthetic resin gel). These gel mediums are designed to be mixed with a small amount of oil paint. The gel takes on the color of the paint with some degree of transparency, giving the illusion of full-bodied paint without the disadvantage of cracking.

Also on the market are specially prepared quick-drying white paints—Winsor & Newton's Underpainting White® and Grumbacher's MG® white—which can be used to build an underpainting with some degree of thickness (impasto) and which when dry can be glazed with color.

Figure 6–4

E. MIXED MEDIA AND MATERIALS

E.1 Mixed Media

Underpainting with dilute acrylic paints in preparation for overpainting or glazing with oil paints is acceptable. However, the acrylic paint layer should be thick because the acrylic film and the subsequent oil film may expand and contract at different rates, causing the oil film to crack.

Using acrylic paint *over* oil paint is *not acceptable* because the acrylic paint will not adhere properly to the oil film.

E.2 Painting Over Old Oil Paintings

Painting over old paint is generally not recommended, but in the case of an art student painting over a recent painting, it should not be a problem. To prepare the surface, first remove any heavy impasto strokes by scraping them down with a painting knife. Second, if the painting has a glossy surface, it should be lightly sanded to roughen it, providing a "tooth" (surface) for the next paint layer. Third, clean the surface with a cotton ball dipped in mineral spirits in order to remove any dirt, dust, or grease. And fourth, apply a thin film of white lead to obliterate the old image.

F. COLLAGE

Applying foreign materials to the painting surface or mixing sand, dry coffee grounds, old paint scrapings, or other materials with oil paint is not recommended; acrylic paints, which have a greater adhesive strength, should be used for this purpose. However, in cer-

tain cases, some procedures are acceptable; for example, applying pieces of cloth or canvas to a surface already primed with an acrylic ground can be accomplished using more acrylic ground preparation as an adhesive. The piece to be applied is simply coated with or dipped in the acrylic preparation and applied to the canvas. Lighter materials (paper, string, and so on) can be made to adhere to the canvas with Elmer's Glue All.

All the techniques described in this chapter may be judiciously mixed together or integrated into one painting — impasto may be employed in direct painting and then followed by a glazed area, and so on. I do not wish to leave the art student with the idea that he or she has to limit each painting to a specific technique — unless that is his or her desire.

G. FINAL VARNISH

A final varnish acts as a seal to protect the surface of the painting from atmospheric pollution, dust, dirt, and so on. It should be easily removable and not yellow (discolor) or crack.

G.1 Natural Resin

G.1(a) Final Varnish

The best choice of a *natural resin* for use as a final varnish is dammar. The formula given in Chapter 4 for making varnish using dammar crystals (10 ounces by weight of dammar crystals to 1 pint of turpentine) is known as a 5-pound-cut varnish (the commercial term for 5 pounds of crystals to 1 gallon of turpentine). For a final varnish, mix 3 parts by volume of this standard dammar solution with 1 part by volume of pure gum turpentine. Apply the varnish to the painting according to the steps in Section G.4.

G.1(b) Retouch Varnish

Retouch varnish is a nonpermanent varnish designed to be applied to an area of the canvas where the color has sunken in and appears dull. The purpose of the retouch varnish is to give that area the same surface appearance as the rest of the painting. This is necessary only to eliminate the optical annoyance of working on a surface that contains dull spots. Retouch varnish does *not* provide a protective film and should not be used as a substitute for a final varnish. Retouch varnish can be made by adding 1 part by volume of turpentine to 1 part by volume of dammar varnish.

G.2 Synthetic Final Varnishes

A synthetic final varnish is perfectly acceptable to use on an oil painting in a spray application (10–15-percent solution of resin syrup). Rohm and Haas's Acryloid B-72 is a good choice when using a final varnish on a painting that has not been painted with a heavy use of resinous varnish (dammar in a glaze medium). The solvent in Acryloid B-72 could possibly dissolve the resinous varnish (dammar), so if a heavy amount of dammar was used, a better choice of final varnish would be a 10–15-percent solution of Acryloid B-67 MT because the solvent in Acryloid B-67 MT will not cause harm to the dammar.

G.3 Beeswax

Beeswax may be used to make dammar varnish less shiny. Melt 4 ounces by volume in 2 ounces of turpentine (over low heat) and add to 10 ounces of dammar varnish (5 pound cut). This should dull the dammar finish sufficiently.

Note: *The mixture of wax with dammar varnish is not a preferred final varnish because the mixture tends to weaken the positive properties of each ingredient. The wax also retards the drying of the dammar, extending the drying period one or two weeks. If the wax-dammar varnish is used, it should be applied by spraying, to insure an even, thin film.*

Another alternative for achieving a dull or mat varnish finish is a thin coating of beeswax mixed with 10 percent carnauba wax or a microcrystalline wax (for hardness of final film), applied by hand to the dried dammar varnish. The wax mixture should be warmed to a paste, applying as little as possible with a soft brush or the palm of the hand. When dry, finish by polishing with a soft lintless cloth.

G.4 Application of the Final Varnish

Before applying the final varnish, allow the painting to dry for at least two to five weeks. When the proper amount of time has passed, the painting may be held in an upright position on an easel to apply the final varnish (several coats) which should be sprayed on with a commercial brand aerosol-spray varnish or a compressed-air spray gun. For brush application, place the painting in a horizontal position. Using a varnish brush, brush the varnish on the painting with strokes going in both directions of the weave (Figure 6–5), followed by **feathering** (light strokes) in one direction. Now allow the painting to dry in a horizontal position in as dust-free an environment as possible.

Figure 6–5

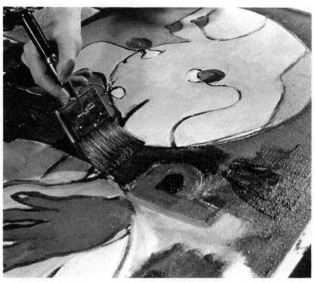

AUXILIARY SERVICES

A. **STORAGE**
 1. **Storage of Unstretched Canvases**
 2. **Storage of Stretched and/or Framed Canvases**

B. **CRATING**
 1. **Preparation of the Painting**
 2. **Crate-building Materials**
 3. **Determining Crate Size**
 4. **Crate Construction**
 5. **Packing the Crate**

C. **PHOTOGRAPHING PAINTINGS**
 1. **Studio Arrangement**
 2. **Photographic Equipment**
 a. *Camera*
 b. *Lenses*
 c. *Exposure meters*
 d. *Illumination (light source)*
 e. *Films*
 f. *Accessories*
 1) TRIPOD
 2) CABLE RELEASE

 3) COLOR FILTERS
 4) CLOSE-UP LENS ATTACHMENTS
 5) STANDARDIZATION AIDS
 3. **Typical Procedure**

D. **NOTES ON THE CONSERVATION OF OIL PAINTINGS**
 1. **The Examination**
 2. **Consolidation**
 3. **Cleaning**
 4. **Cosmetic Treatment**
 5. **Typical Example**
 a. *Consolidation*
 1) FACING
 2) LINING
 3) REMOVING THE FACING
 b. *Cleaning*
 1) CLEANING SURFACE ACCRETION
 2) CLEANING RESINOUS VARNISHES
 c. *Cosmetic Treatment*
 1) PRIMARY RESURFACING
 2) INPAINTING
 3) FINAL VARNISH

AUXILIARY
SERVICES

Chapter Seven

AUXILIARY SERVICES

This chapter is concerned with procedures that may be necessary *after* the painting is completed. These auxiliary services include the storage, crating, and photographing of paintings and some **conservation/restoration** techniques.

A. STORAGE

Storage space or lack of it is a problem common to all artists. Artists are reluctant to yield working space for storage space, yet failure to provide adequate storage inevitably leads to damaged works and poorly utilized space. The following material is offered to the reader as a possible solution to the problem.

A.1 Storage of Unstretched Canvases

When finished works are to be stored for a long period they may be taken off the stretcher or support and layed flat (size permitting) in a large map-case drawer. They should be separated by 100-percent-acid-free mat board. Paintings too large for a map case may be rolled, painted side out (to minimize the stress on the paint film), around a large-diameter cardboard or wood cylinder. If they are thoroughly dried, several paintings may be successively rolled in this manner.

For storage periods of shorter duration, unstretched canvases may be stored by stapling them to a wall. Allow the canvas to hang free without folds by stapling only across the top edge. Successive canvases may be placed over the first and affixed in the same way.

A.2 Storage of Stretched and/or Framed Canvases

Leaning several paintings one upon the other against a wall is the least desirable of storage methods. However, if one is forced by financial constraint to use such a method, certain minimum precautions should be observed. The paintings should at the very least be raised off the floor by means of 2x4-inch boards and separated by oversized sheets of corrugated cardboard.

Prefabricated bolted (for easy removal

Figure 7–1

and reassembly) vertical storage racks are preferred to random stacking whenever possible. Such a system was recently designed and installed at Georgetown University for their art collection. The system uses **modular** side units of 4x8-foot by 3/4-inch plywood with 2x4-foot by 3/4-inch top and bottom units for each compartment. Predrilled and **countersunk** holes were used with a nut-and-bolt assembly; 2x4-inch pine lumber was used for lending structural strength and for joining the units together (Figures 7–1, 7–2).

Figure 7–3 illustrates a deluxe, museum-quality storage area. These metal racks at the National Collection of Fine Arts, Smithsonian Institution, Washington, D.C., are hung on rollers, so that an individual rack can be rolled out into the center of the room for easy access to the paintings. Because the paintings are hung by screw eyes attached to the frames, it is imperative that the screw eyes are checked periodically for looseness. Such a system is no doubt too

Figure 7–2

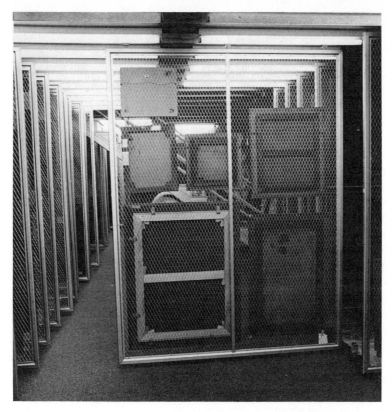

Figure 7–3

elaborate and expensive for an individual artist's studio, but it is included here to demonstrate the wide range of storage possibilities.

B. CRATING

B.1 Preparation of the Painting

Before any discussion of the construction of a shipping crate is begun, some comments are in order concerning the preparation of the painting for shipping.

a. The painting should first be photographed with color print or color slide film for your records in the event of loss or damage in shipping. Make out a brief condition report regarding any existing damage to the painting or frame.

b. Check the corner keys to see that they are securely in place. Let fall a drop or two of hot candle wax between the keys and stretcher to prevent the keys from becoming loose and falling out during shipment.

c. The painting should have some protection from accidental damage from the reverse side. To prevent damage during storage, handling, or shipping screw to the stretcher a backing that is slightly smaller than the stretcher and made of Fome-Cor® board (Monsanto) or heavy cardboard (*not* corrugated cardboard—too weak) using flathead wood screws with countersink washers. Exercise caution in making sure that the screws are not long enough to go through the stretcher and damage the canvas.

d. Make sure the painting is secure in its frame—but never nail the painting to the frame. The hammer blows cause un-

due stress on the stretcher bars, and a misplaced blow may damage the canvas; moreover, nails do not hold very well. Nails also do not allow the canvas to "float" in the frame, permitting the painting to expand and contract.

The proper method of attaching the painting in the frame is with brass **straps**. These straps, available in a variety of lengths, are predrilled with countersunk screw holes designed to accept small brass screws. Use a minimum of six straps, two on each of the long sides and one on each short side of the painting. The straps can be bent to create a springlike pressure on the painting when the other end is attached to the frame. It is not necessary to attach the end to the painting stretcher, for the pressure caused by the bend in the strap will hold the painting in place. Figure 7–4 shows the backing and straps in place.

e. Remove all protruding screw eyes and hanging wire. You should replace

Figure 7–4

the screw eyes with a hanger that screws into the stretcher and folds flat. The painting in its frame is now ready for crating.

B.2 Crate-Building Materials

The following is a list of some of the basic crate-building materials:

a. 3/4-inch-thick sheet plywood
b. white pine boards
c. nails
d. flathead wood screws
e. countersink washers for the screws
f. padding material (Kimpak ® [Kimberly & Clark])
g. waterproof paper [Glas-Kraft, Inc.]
h. glassine paper or brown wrapping paper or Mylar®
i. large sheets of corrugated cardboard

B.3 Determining Crate Size

Every crate is a separate design problem for the individual painting to be shipped. There are some general guidelines, however, worth stating. The way to determine the interior size of the crate is to add approximately 2 inches each to the length and width of the painting and 4 inches to the depth of the painting and frame. This space will later be filled with packing materials. The object here is to provide enough space to "float" the painting—to isolate it from the direct transmission of shocks and blows occurring in transit. It is also essential that the painting be prevented from shifting within the crate.

B.4 Crate Construction

Single-painting crates are usually designed to be packed and opened in a

horizontal position, utilizing one whole side (plywood) as a lid or cover. All parts of the crate should be constructed with nails, with the exception of the top cover, which is held in place with flathead wood screws and countersink washers. The top cover can then be easily removed and reused for future shipment.

The collar of the crate—that is, its perimeter and depth dimension—is usually made of pine board, but it may be constructed from the same sheet of plywood to be used for the top and bottom. The collar should be fabricated first to form the basic frame for the crate. The bottom, usually 3/4-inch plywood, can then be attached with nails. The top cover can be set in place and holes drilled for the screws through the top and into the collar. Be sure to mark the top and collar so as to permanently record the proper alignment of the holes. The size of the drill should be the size of the core of the screw, not the thread size. This can be determined by holding the screw and the drill end to end and observing the solid core of the screw. At this point, exterior struts and cross-braces of 1x3-inch pine can be nailed around the girth of the crate. This will give the crate added strength and provide the freight handler with a means of holding the crate. A final check should be made to see that no nails are protruding into the interior surface of the crate.

Occasionally, battens, or removable interior braces, may be employed to hold the painting in place. These are easily constructed from 1x3-inch pine strips with blocks or cleats attached to each end. The cleats should be predrilled for screws for subsequent attachment to the inside collar of the crate. The battens will be the last items to be installed and will hold all the contents in place.

B.5 Packing the Crate

With the bottom complete with braces and joined to the collar, the packing process can begin. Observe the following steps:

STEP 1. Line the interior of the crate with a specially laminated waterproof paper that is two layers of paper with an asphalt core. Use glue rather than staples for this process in order to make the paper adhere closely to the wood. Be sure to glue the waterproof paper liner to the inside of the top cover.

STEP 2. Cut a piece of corrugated cardboard to fit the inside and place it in the bottom of the crate.

STEP 3. At this point, we turn our attention to the painting itself. The painting may be wrapped with **glassine paper**, brown wrapping paper, or **Mylar** to protect it from dust and dirt. If the painting is small enough, a box can be fabricated from corrugated cardboard to surround the painting and then the boxed painting placed inside the crate.

One important precaution: make sure the covering is *not* airtight. Therefore, do not use plastic sheeting to wrap the painting: given certain changes in temperature, the painting and the frame can extrude moisture which may then condense on the inner sides of the plastic covering, causing moisture damage to the painted surface. Also, be sure to use removable masking tape so that the wrapping may be unfolded rather than torn.

The next and most important step is to cover the corners of the frame with **Kimpak** paper padding. Kimpak is a soft laminated paper which is very flexible and quite shock-absorbent. Cut the Kimpak from the roll into strips and fold the

latter into tubelike forms. Then wrap these lengths of Kimpak diagonally around the front of the frame corners and staple them to the back of the frame. These corner pads are the key cushioning devices for the painting. They should be generous, but not excessive. The painting may now be placed painted side down in the bottom of the crate.

STEP 4. Adjust the painting so that there is an equal space between the sides of the painting and the crate. Then carefully fit this space with several rolled tubes of Kimpak material. The material should be compressed and stuffed into all of the existing space until the painting cannot shift in any direction. Never use loose or covered **excelsior** for packing a work of art. It is too flammable, rough, and difficult to remove from the crate and painting surfaces. Likewise, styrofoam beads are insufficient protection in a crate of this type.

STEP 5. Cut another corrugated cardboard separator and place it on top of the

painting. If the crate was designed to hold more than one painting, the second painting would now be placed on top of the cardboard and Steps 3, 4, and 5 repeated.

STEP 6. The wood battens with cleats are now put in position on the cardboard and secured with screws from either the inside or outside of the crate. The battens should apply an even, gentle pressure on the cardboard to prevent the painting from shifting within the depth of the collar of the crate.

STEP 7. The next step is to screw the top cover in place, observing the marks indicating the proper relationship of the predrilled holes.

STEP 8. The last step is to apply all the necessary markings, which include an indication of which side to *open* and which *not to open* and of which end is up, a "handle with care—fragile" stencil on all sides, and perhaps the symbol for fragile objects, a broken wineglass (Figure 7–5). All previous labels should be

Figure 7–5

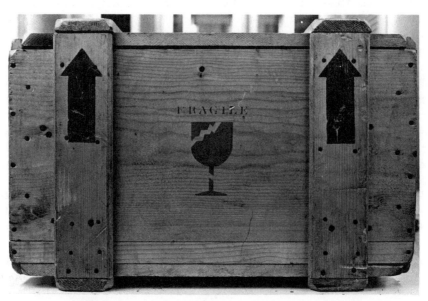

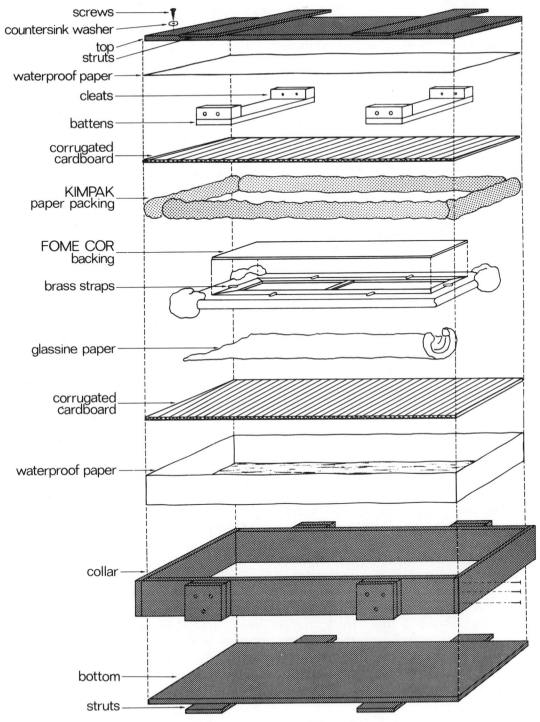

screws

countersink washer

top
struts

waterproof paper

cleats

battens

corrugated
cardboard

KIMPAK
paper packing

FOME COR
backing

brass straps

glassine paper

corrugated
cardboard

waterproof paper

collar

bottom

struts

Figure 7–6

95

obliterated or removed and *one* shipping label attached. Figure 7–6 shows a diagram of a crate and contents such as described in this section.

The size of the crate, its destination, and so on will determine the choice of freight carrier. Be sure to inquire about the freight carrier's insurance for fine arts objects. A crate showing the freight carrier's seal or label of insurance usually receives better care. Some shippers and freight carriers offer door-to-door delivery, while others deliver to their substation, where the receiver must pick up the crate. Be sure you and your receiving agent have the proper understanding of the delivery process.

C. PHOTOGRAPHING PAINTINGS

C.1 Studio Arrangement

In order to discuss the photography of paintings, the author will have to assume some general knowledge on the part of the reader concerning the operation of a camera. With the basic knowledge of how to read a photographic **exposure meter** and an understanding of **shutter speed** and **aperture** settings, photographing a painting should not be difficult. With that in mind, the first step is to determine what form the photographic end product will assume. Does the artist wish color transparencies (slides) of his paintings, color prints, color transparencies for reproducing the painting in an exhibition catalog, or black-and-white prints? Each of the above photographic products will be dealt with in turn.

Regardless of which film, camera, and so forth are employed, the studio arrangement remains the same. It is best to work in a room temporarily or permanently converted into a photo studio to retain total control of the lighting of the painting. The space should be windowless or with light-sealed windows and be large enough to adjust the photographic lights at various distances from the painting. One wall, against which the painting will be photographed, should be painted mat black; alternatively, a large roll of photographic seamless black paper may be fixed to the wall. Next is needed a sturdy easel adjusted to a completely vertical position; or, for permanent installation, an inexpensive easel can be taken apart and the vertical painting support with attached crossbars nailed to the wall. If a free-standing easel is used, mark the floor with masking or plastic tape indicating the position of the legs. Since the camera must be in a direct line with the center of the easel and perpendicular to it, such a line should be indicated by affixing tape to the floor. If the floor is tiled or seamed perpendicular to the wall, the easel can be set up in relation to that seam and the need for marking the floor eliminated.

C.2 Photographic Equipment

C.2(a) Camera

For making color transparencies (slides) and/or color prints for personal use, a 35-mm single-lens reflex camera with interchangeable lenses is the most practical. A through-the-lens metering system is not necessary, since a handheld meter is more effective in photographing paintings. For a larger color transparency or color negative for making color prints, a camera with a $2\frac{1}{4}$ x $2\frac{1}{4}$-inch focusing screen and a nega-

tive of the same size lend themselves more readily to detail focusing and careful alignment of the painting in the viewing screen. For extralarge color transparencies or negatives (4x5 inches or 8x10 inches), a view camera is needed. A view camera differs from the reflex camera in that the image is projected directly through the lens onto a ground glass focusing screen, whereas in a reflex camera the image is reflected off an inner mirror onto the viewing screen.

A larger format is particularly desirable when the transparency is going to be used in making a graphic reproduction of the painting, such as a color plate in a book or catalog or a color plate in a poster. The increased format size allows more room for the inclusion of the Eastman Kodak **Color Control Patches**®, described in Section C.2(f.5), or other standardization scales for the benefit of the graphic arts printer.

C.2(b) Lenses

The normal lens should be all that is necessary for routine copy work. A wide-angle lens may be used when the painting is large and the camera cannot be moved back far enough to include it all on the negative, since the wide-angle lens takes in more area in any given position. The danger in the use of an extreme wide-angle lens (one wider than 28 mm on a 35-mm camera) is that distortion (a bowing out of the top and sides of the image called **"barreling"**) will occur in the photograph. Telephoto (long) lenses are used to photograph a more restricted area of the painting. They can enlarge an area without moving the camera closer to the painting and facing the problem of distortion and interference with the light source. A 100-mm or 125-mm telephoto lens (for a 35-mm camera) should meet most needs. Regardless of the choice of lenses, an accessory lens shade should always be used to prevent any extraneous light from entering the lens.

C.2(c) Exposure Meters

A quality handheld exposure (light) meter designed to read the light reflected off the subject (reflected-light reading) or to read the light that falls on the subject (incident-light reading) should be used. The meter should be operable for a wide range of film sensitivity (**ASA** numbers) and perform both high-level and low-light level readings. The final desirable characteristic is a locking device for the meter's needle: this allows you to "freeze" the needle at the correct light level and gives you time to compute the camera setting.

C.2(d) Illumination (Light Source)

Natural daylight has been eliminated from this discussion because it is unpredictable within a given time period and certainly from day to day. Therefore, in an effort to exercise total control and be able to repeat successful photographic sessions (predicated on the fact that you will record all the relevant data of your photographic experiments — exposure, lens, film, and so on), artificial light sources should be used. Also excluded are flashbulbs, electronic flash units, and fluorescent lamps. Flash units, although they have been successfully used by skilled technicians, do not allow the average photographer time to carefully arrange the angle and degree of light, to determine exposure, or to avoid reflection off the surface of the painting. Fluo-

rescent lamps may be suitable for some black-and-white photography, but they do not have the right color spectrum compatibility with most color films. Color correction is possible with the use of **filters**, but it is a complicated procedure and yields results that may still be unsatisfactory.

Recommended here are two free-standing, adjustable light stands with collapsible tripod legs or two bases with wheels on which are attached studio lights. The studio light consists of a bowl-shaped reflector that accepts a **photolamp** or **tungsten lamp**, or a self-contained unit equipped with a color-temperature-controlled **quartz-iodine lamp**. Adjustable shields or flaps called **barndoors** attached to the reflector will help confine the light to a given area and will control the shape and direction of the beam.

The sources of illumination should be tungsten lamps rated at 3200K (**Kelvin degrees** — the color temperature), photolamps rated at 3400K, or quartz-iodine lamps rated at 3200K.

C.2(e) Films

Color films are designed to produce either prints or transparencies. Film that yields color prints is referred to as a color negative film because a negative is exposed from which prints and enlargements are made. Film that produces color slides is referred to as color reversal film.

The most significant difference between films beyond such subtle characteristics as color rendition and sharpness is the film speed. Film speed is a measure of the film's sensitivity to light and is indicated by the ASA (American Standards Association) number — the higher the ASA number, the less light needed for producing a successful photograph. The highly useful chart in Figure 7–7, taken from Eastman Kodak Customer Service Pamphlet AE-41, *Kodak Color Films for Still Cameras*, p. 7, shows the types of films available with complete relevant data regarding them.

The following film and illumination choices are most used in photographing paintings: for color prints — Kodak Ektacolor Professional type S (for short exposure), code name CPS, used with a lens filter for tungsten 3200K lamps. For color slides — Kodak High Speed Ektachrome type B (for tungsten), code name EHB; this film made for use with tungsten 3200K lamps, and has a high ASA number. For black-and-white prints, Kodak Tri-X film is the best choice (temperature of the lamps is not important in black-and-white photography).

C.2(f) Accessories

The following list of accessories should complete the equipment needed to do a careful and accurate job of photographing a painting.

C.2(f.1) TRIPOD. A sturdy, professional camera tripod with adjustable center post and legs is essential. Sharp pictures, long exposures, and ease of alignment would be impossible without a good, steady tripod.

C.2(f.2) CABLE RELEASE. A flexible-shaft cable release should be used to release the camera shutter. Using a cable release prevents the photographer from transmitting any hand vibration or other movement to the camera. It is essential in long exposures to avoid vibration.

KODAK Color Films for Still Cameras

KODAK Color Film	Type of Picture	For Use With	Film Speed (ASA) and Filter			Sizes Available	Processing By
			Daylight	Photolamps 3400 K	Tungsten 3200 K		
KODACOLOR-X (CX)	Color Prints	Daylight, Blue Flash, or Electronic Flash	80	25 No. 80B	20 No. 80A	828, 127, 620 120, 616, 116	Kodak, other labs, or users Process C-22
KODACOLOR II (C)	Color Prints	Daylight, Blue Flash, or Electronic Flash	80	25 No. 80B	20 No. 80A	135-20, 135-36 126-12, 126-20 110-12, 110-20	Kodak Process C-41, other labs, or users
EKTACOLOR Professional, Type S (CPS)	Color Prints		100	32 No. 80B	25 No. 80A	135-36 620, 120, 220	Kodak, other labs, or users Process C-22
KODACHROME 25 (Daylight)(KM)	Color Slides	Daylight, Blue Flash, or Electronic Flash	25	8 No. 80B	6 No. 80A	135-20, 135-36 828	Kodak and other labs
KODACHROME II Professional (Type A)(KPA)	Color Slides	Photolamps 3400 K	25 No. 85	40	32 No. 82A	135-36	Kodak and other labs
KODACHROME 64 (KR)	Color Slides	Daylight, Blue Flash, or Electronic Flash	64	20 No. 80B	16 No. 80A	135-20, 135-36 126-20, 110-20	Kodak and other labs
EKTACHROME-X (EX)	Color Slides	Daylight, Blue Flash, or Electronic Flash	64	20 No. 80B	16 No. 80A	135-20, 135-36 110-20, 126-20 828, 127, 620, 120	Kodak, other labs, or users Process E-4
EKTACHROME Professional, Daylight Type (Process E-3)(EP)	Color Slides		50	NR	NR	120	Other labs or users Process E-3
EKTACHROME Professional, Type B (Process E-3) (EPB)	Color Slides	Tungsten 3200 K	25 No. 85B	25 No. 81A	32	120	Other labs or users Process E-3
High Speed EKTACHROME* (Daylight)(EH)	Color Slides	Daylight, Blue Flash, or Electronic Flash	160 / 400+	50 No. 80B / 125+ No. 80B	40 No. 80A / 100+ No. 80A	135-20, 135-36 126-20, 120	Kodak, other labs, or users Process E-4
High Speed EKTACHROME (Tungsten)(EHB)	Color Slides	Tungsten 3200 K or Existing Tungsten Light	80 No. 85B / 200+ No. 85B	100 No. 81A / 250+ No. 81A	125 / 320+	135-20, 135-36 120	Kodak, other labs, or users Process E-4

*Not recommended for simple (nonadjustable) cameras.

+With KODAK High Speed EKTACHROME Film, 120 or 135 size, and ESP-1 processing.

NR—Not Recommended

Figure 7-7

C.2(f.3) COLOR FILTERS. Color filters are used to correct or balance the color sensitivity of film not designed primarily for the illumination at hand. Filters are relatively inexpensive and fit over or screw into the camera lens. Filters are designated by their Kodak **Wratten** numbers. If you wanted to use all the Kodak color films listed in Figure 7–7 with all possible sources of illumination, you could accomplish this with five filters: Kodak Wratten numbers 80A, 80B, 81A, 85, and 85B.

Occasionally, the surface of a painting may be excessively shiny, slick, or heavy with thick paint, making it impossible to illuminate the painting without glare. In such cases it may be necessary to use **polarizing** filters on the lights and on the camera lens. The polarized light in combination with the adjustable filter on the camera lens can screen out most of the surface glare. The use of polarizing filters does not affect the color rendition of the film and in fact may make the color of the painting appear richer. Polarizing filters come with detailed instructions for use.

One last filter, which can help predict the final result and check the lighting on the painting, is not used on the camera lens but is held up to the photographer's naked eye: this is a **color-tone viewer**, which allows you to see the painting as the *film* will see it, the film being less sensitive than the human eye.

C.2(f.4) CLOSE-UP-LENS ATTACHMENTS. Small filterlike lenses, which can be screwed onto your normal camera lens and will not affect the color rendition or exposure time of the film, magnify the image and can be used for close-up or detailed photography of the painting.

Such attachments are approximately the same price as filters, and their degree of magnification is indicated by the plus numbers on the lens—for example, closeup +1, +2, +4, and so on (higher numbers indicating greater magnification).

C.2(f.5) STANDARDIZATION AIDS. In producing a color transparency that will be printed in a book or catalog, it is very helpful for the painter to include a Kodak Color Control Patches card in the transparency. The color-control card is composed of eight standard graphic ink colors. Thus color patches in the transparency can be compared in appearance to the graphic arts printer's color-patches card to ascertain the faithfulness of the color reproduction. The printer can then correct any color imbalance before printing with appropriate filters. The inclusion of the Kodak Color Control Patches card also provides the photographer with a means of comparing the results of his work. The equivalent for black-and-white photography would be the Kodak **Standard Gray Scale** ® card, whose ten-unit gray scale from white to black permits a visual evaluation of the exposure of the negative. **Register marks** (cross-lines in a circle) should also be included on the Kodak Color Control Patches card to aid the graphic arts printer in reassembling his color separations.

A Kodak **Gray Card** is printed with a neutral 18-percent-reflectance gray. This card is used to take an average reflective reading with a light meter when the painting contains both very dark and very light areas. The reading from the gray card held at the surface of the painting will indicate a good average exposure.

C.3 Typical Procedure

To state a hypothetical case, let us assume an artist needs a 35-mm slide of one of his or her paintings. Using an indoor studio, the film choice would be Kodak High Speed Ektachrome, type B, with two 250-watt tungsten 3200K lamps for illumination. Under these conditions, the ASA rating of the film is 125 with no filter.

The painting is placed in the center of the easel with the longest sides in a vertical position. Because light becomes less intense at the edges of the beam and since the painting will be lit from the sides, it will be easier to illuminate it evenly if the width of the painting is as narrow as possible, which means that the painting may not be in its normal viewing position. The surface of the painting should be checked with a carpenter's level or **plumb bob** to be sure that it is perfectly vertical.

At this point, the photographer may include a Kodak Color Control Patches card and/or a Kodak Register Marks Card along the top or bottom of the painting (attached to the easel at the same level as the painting surface).

The tripod with the camera attached should be placed in line with the center of the easel (as previously described in Section C.1). The camera should be mounted to the tripod head in a vertical position to correspond to the position of the painting on the easel. The flat back of the camera should be parallel to the painting surface; the cable release should be attached and the shutter cocked.

To determine the correct height of the camera, which should be the same as the direct center of the painting, measure the vertical length of the painting, divide by 2, and add the distance from the bottom of the painting to the floor. For example, if the painting is 30 inches high, this dimension divided by 2 is 15 inches; and if the bottom of the painting is 40 inches from the floor, the center of the painting is then 40 inches plus 15 inches, or 55 inches. The camera should thus be adjusted so that the center of the lens is 55 inches from the floor.

Set the two lights at approximately the same distance from the painting, one on each side of the painting, at 45 degrees from the axis running from camera to painting, and adjust the lights to the height of the center of the painting. The barndoors on the reflectors can be adjusted to direct the light on to the surface of the painting. The shadows created by a pencil held vertically at the painting surface can help determine the equidis-

Figure 7–8

tance of the lights: the pencil should cast two shadows of equal density (darkness) and form a symmetrical pattern (Figure 7–8). The density of the shadow is determined by the closeness of the lamps; the pattern is determined by the height and angle of the lamps.

A quick check at the camera position with a color-tone viewer will reveal any hotspots of light on the painting. If that is the condition, the lights should be moved further away from the painting to achieve a more even illumination. Incident light-meter readings taken at the four corners of the painting can also help to determine evenness of illumination. Figure 7–9 is a diagram of a typical lighting arrangement.

To determine exposure, set the light meter at ASA 125 and take an incidental light reading as close to the painting's surface as possible. A reflective light

Figure 7–9

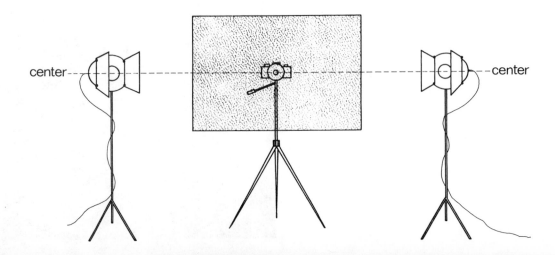

top view

picture wall

45° 45°

equal distance

front view (thru picture)

center center

reading may be taken from an 18-percent gray card held close to the painting's surface. Be careful not to allow any shadows to fall on the gray card when taking this reading. The setting on the camera should favor as small an aperture (**f-stop**) as possible in order to obtain critical sharpness. The shutter speed may be as slow as 1/10 second, but exposures longer than 1/10 of a second may require special filtration and exposure compensation.

The camera should be focused, the setting adjusted to the meter reading, and the picture taken. Two additional shots should be taken, one with the *f*-stop set a half-stop higher and one with it a half-stop lower than the meter reading. "Bracketing" the exposure thus increases the possibility of a successful photograph.

D. NOTES ON THE CONSERVATION OF OIL PAINTINGS

In making suggestions to the artist regarding the conservation of oil paintings on fabrics old and new, the analogy to medical self-treatment is remarkably apt. Along these lines, the information given in this section should be considered more in the way of (1) determining the severity of the damage, (2) providing temporary "first aid" until the painting is delivered to professional **conservator**, and (3) administering minor treatment that can be accomplished in the home studio. Severe damage should always be referred to a local professional conservator. The American Institute of Conservation of Historic and Artistic Works, River Street, Cooperstown, New York 13326 can be helpful in locating qualified conservators.

This section is divided into four major parts, covering examination, consolidation, cleaning, and cosmetic treatment of the painting.

D.1 The Examination

During the examination of the painting, the condition of the support (fabric, stretcher, and so on) should be determined. Is the fabric sagging between the stretcher? Is it torn from the nails or staples holding it to the stretcher? Is the stretcher intact? Serviceable? Are there rips, tears, or holes in the fabric? (Minor rips, tears, and holes can be treated.)

Next, determine the condition of the paint film. Is it bonded to the fabric? Is it **flaking**? If it is flaking, is the paint film and the ground (e.g., white lead) still bonded, or is the paint film separating from the ground (a much severer problem)? Is the paint film cracked (**craquelure**) or **cupped** into dishlike shapes? Keep in mind that extremely loose or flaking paint over a large area (5 percent or more of the painting) or in a critical area of the painting, such as paint loss on the face of a portrait, should be referred to a professional conservator.

If one takes notes during such an examination of the art work to be restored, after reading the next three sections (D.2, D.3, and D.4) the intelligent reader can determine independently what can be effectively done in the studio and when to seek the help of a professional conservator.

D.2 Consolidation

Consolidation of a painting involves reinforcing and restructuring the support system, attaching or reattaching loose and/or flaking paint, and, finally,

immobilizing the paint layer. The phases in the consolidation process include **facing** the painting and **lining** the painting.

D.3 Cleaning

Cleaning a painting includes removing surface accretion (dirt, smoke film, pollution films, and so on), resinous varnish films, and former or old retouched or repainted areas.

D.4 Cosmetic Treatment

The term **cosmetic treatment** implies techniques that for the most part aid the aesthetic perception of the painting. The cosmetic treatment does in effect resurface the painting.

D.5 Typical Example

In order to best describe the various techniques and their sequence, I have included in this section a typical example of how to handle a painting in need of conservation. However, keep in mind that each painting is quite unique in its problems and recommended treatment. Assume that the examination phase has revealed the existence of the following conditions: (1) some small areas of paint loss where the fabric (linen) is exposed; (2) in several small clustered areas, very loose and flaking paint film (still adhering to the white lead ground); (3) one pencil-sized hole and a 3-inch knife cut throught the fabric; (4) edges on the sides of the painting that are **abraded** and frayed from having rubbed against the frame, although the stretcher is in good condition and reusable; (5) a surface coating of yellowed resinous varnish.

After the examination phase, the painting should be photographed if there is no danger of paint loss.

D.5(a) Consolidation

D.5(a.1) FACING. The first and most important problem to attend to on our damaged painting is the flaking paint and the tear. To immediately immobilize and stablize the surface, the painting should be faced with a protective covering. The facing is made from **mulberry tissue** soaked in a weak adhesive, which upon drying becomes stiff. The facing will enable you to deliver or ship the painting to a professional conservator or allow you to continue to work on it yourself with greatly reduced risks. The facing procedure is described in the following steps:

STEP 1. If the surface of the painting does not have large and deep cracks and has a good varnish coating, a water-soluble adhesive may be used. A dilute solution of wheat-flour paste (wallpaper paste) mixed with water to the consistency of heavy cream would be a good choice. If there is no varnish on the painting, or if there are large cracks and **fissures** in the surface, there is a danger in using a water-soluble adhesive because the water can dissolve the sizing and loosen the ground. Acryloid B-67 MT should then be substituted for the wheat paste and water. B-67 MT is supplied from the manufacturer in a 45-percent solid resin solution of mineral spirits. The concentration of the solution should be reduced to approximately 20 percent by adding more mineral spirits: mix 1 part by volume of the 45-percent B-67 MT solution with 1 part by volume of mineral spirits.

Figure 7–10

STEP 2. Place the painting face up on a clean table. The tear in the painting should be temporarily supported from the back of the canvas (with a small block or book) to bring it to the level of the rest of the painting's surface. Adjust the tear as closely as possible to its original position. Carefully remove extraneous threads without disturbing the paint film at the edge of the tear.

STEP 3. Beginning at the center of the painting, carefully lay a 4x4-inch piece of mulberry tissue on the surface.

STEP 4. Brush the solution (wheat paste or B-67 MT) over the top of the tissue and saturate it (Figure 7–10).

STEP 5. Continue to repeat Steps 3 and 4, overlapping the edges of the tissue squares by a 1/4 inch, until the face of the painting is entirely covered and the tissue completely bonded to the paint layer.

Note: *It is essential to remember that after facing the painting it must be consolidated from the reverse side by lining before the facing is removed.*

D.5(a.2) LINING. Lining involves the bonding of a new support fabric (linen or Fiberglas ®) to the back of the existing fabric with a wax/resin adhesive. The wax in the adhesive mixture should be a good-quality microcrystalline wax with a

melting point of approximately 155°F. Bareco Company's Ultraflex is one good choice for a wax, while Pennsylvania Chemical's Piccolite ® no. S115 or S100 is a good-quality resin to use in the mixture. An average formula would be 5 parts of wax (by weight) to 1 part of resin (by weight). When using Fiberglas cloth for a new support fabric, because the wax has little adhesive strength and acts largely as a vehicle for the resin a stronger adhesive mixture should be made by reducing the amount of wax in the formula—for example, 3 parts wax (by weight) to 1 part resin (by weight).

Versions of all of the materials suggested in this section on conservation can be obtained from the Talas Company.

In a room with proper ventilation, melt the wax and resin together in a double boiler set at a low heat. This mixture should be heated and stirred until thoroughly mixed. *Caution: All materials are flammable.*

The lining procedure is divided into two parts: preparation of the new support fabric, and preparation of the original support fabric.

Part I: Preparing the New Support Fabric

STEP 1. Using canvas-stretching pliers, tightly stretch a piece of linen 4 inches longer and 4 inches wider than the original fabric (including the tackover edge) on a 2x2-inch wood strainer as described in Chapter 2. The strainer will be removed after the two fabrics are bonded.

STEP 2. Place the stretched fabric face down on a clean table covered with glassine or Mylar to prevent the penetrating hot wax/resin from sticking to the table.

STEP 3. With a brush, liberally apply the hot wax/resin mixture to the back of the fabric, beginning at the center and working out toward the edges (Figure 7–11). The wax will cool quickly, making brushing out the wax/resin difficult and not really necessary.

STEP 4. Using an old flat iron (not steam) at the lowest setting, test the heat of the iron on a glob of wax/resin placed on an extra piece of Mylar. The wax should melt smoothly—*but* it is critical that the wax *not* burn. Burning is indicated when the wax sample *foams* instead of melts.

STEP 5. To insure impregnation of the fabric, the hot wax/resin should be distributed over the fabric with a 2-ounce "jigger" or small tumbler glass. Melt a 6-inch-diameter area of wax/resin with the iron at its tested setting (Figure 7–12), and using the inverted tumbler glass start at the center of the puddle and slowly, with very gentle pressure, spiral outward (Figure 7–13). Occasionally glide the glass from the center to the edge of the puddle as if smoothing a wrinkle from a table cloth. This process should smooth the wax/resin, remove the excess, and distribute the wax/resin evenly over the surface. Excess wax/resin that accumulates on the rim of the glass should periodically be removed with a spatula.

The success of this step can be assessed by occasionally observing the front side of the fabric. The wax/resin should fully penetrate to the Mylar on the opposite side without creating an

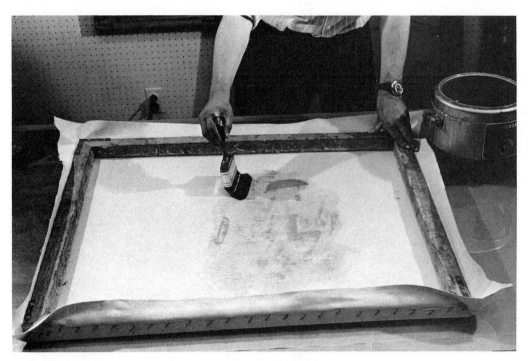

Figure 7–11

Figure 7–12

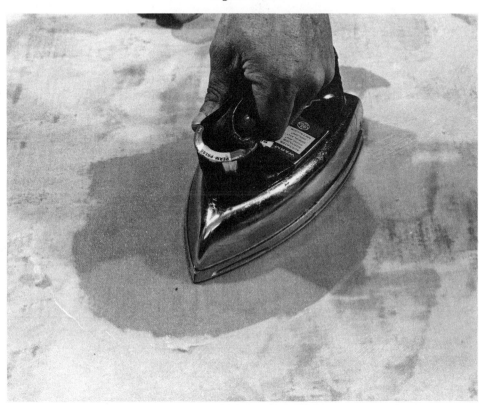

Figure 7–13

unevenness (lumps) in the adhesive between the fabric and the Mylar.

Applying the wax/resin to the new support fabric first gives you an opportunity to develop proficiency in the alternate iron–melt–glass-cupping technique. Because there is great possibility of burning the pigments on the faced painting, it is important to master this step before attempting to apply the wax/resin to the back of the faced painting, as described in Part II of this section.

STEP 6. Place the new support fabric, which is attached to the strainer, aside to cool.

Part II: Preparing the Original Support Fabric

STEP 1. The work table should be cleaned and covered with felt or bunting material to act an a cushion for any raised paint (brush strokes) on the surface of the original painting. This will prevent the raised paint from being flattened against the hard surface of the table during the lining process. Cover the felt or bunting material with a sheet of Mylar.

STEP 2. Carefully place the painting face down, remove the original stretcher, and put it aside.

STEP 3. Using great care, flatten the edges of the painting as best as possible. These tack-over edges should be retained and never cut, so as to preserve the true size of the original painting. Next, as carefully as possible, remove the accumulation of dust and dirt from the fabric with a soft brush.

STEP 4. Repeat Steps 3, 4, and 5 of Part I.

Caution: *Be sure to double-check the temperature of the iron. If the wax foams and burns, so will the paint layer. Many paintings have been destroyed by an iron that was too hot.*

STEP 5. After the application of the wax/resin to the old support fabric is complete and the material is cool, with the painting still in position on the table remove the Mylar from the face of the new support fabric (on the strainer) and place the new support on the back of the original fabric. Align the new fabric so that the weave on the back of the original painting matches the weave of the new fabric as closely as possible.

STEP 6. Bond the two support fabrics together by repeating the iron–melt–glass-cupping technique once again.

STEP 7. Allow the bonded fabrics to cool, turn the painting over, and remove the Mylar from the facing. The wax/resin normally will penetrate through the facing, reattaching any loose paint.

D.5(a.3) REMOVING THE FACING. To remove a facing that has been made to adhere with a wheat-paste/water adhesive, perform the following steps:

STEP 1. Remove the excess wax/resin

Figure 7–14

by rolling a Q-tip® dipped in mineral spirits over the surface, covering a small area at a time. The mineral spirits will dissolve the excess wax/resin and pick it up. Allow the facing to dry.

STEP 2. Remove the facing by soaking a small area at a time with a cotton ball saturated with water. Allow the water to soak the tissue, and when it is softened remove the tissue, lifting it first from an edge (Figure 7–14). If the lifting process meets with resistance, continue to soak the area until it lifts easily. *DO NOT FLOOD THE PAINTING WITH WATER.* If the water does not affect the tissue, it means that the wax/resin excess is not fully dissolved.

If Acryloid B-67 MT was used as a facing adhesive, the mineral spirits will remove the excess wax/resin *and* the facing tissue in one step.

After all the facing tissue has been removed, continue (using Q-tips) to remove any excess wax/resin on the surface of the painting. At this point, the painting can be held at an oblique angle to the light and the surface observed for any irregularities, especially lumps between the old and new fabric supports. If lumps (of wax/resin) still exist, prepare the work table with felt and Mylar and, using the tip of the iron on the back of the painting, remelt and glass-cup the affected area until smooth.

The painting is now consolidated. At this point in the conservation process, the temporary strainer should be removed, the cleaned original stretcher put in place, and the painting restretched on it.

D.5(b) Cleaning

This section of the conservation treatment must be approached with EX-TREME caution. For it is during the cleaning stage of conservation that most of the damage occurs. The purpose of the cleaning process is to remove *only* the surface accretion and the old resinous varnish and *not* the paint film. The difficulty of the process is compounded by the fact that the artist may have used a resinous (dammar) medium to apply glazes and so forth. Since the solvent used to dissolve the resinous varnish layer has the potential for dissolving the glazed paint film, *EXTREME* caution and keen observation must be used during the cleaning process.

To prepare for this procedure, you need a clean work table with a strong light. The first phase in the cleaning of our hypothetical painting will be the removal of the surface accretion.

The tool and technique that will be used throughout the entire cleaning process, regardless of the solvent, will be a saturated Q-tip rolled over a small area (1 1/2 to 2 inches square). This technique should dissolve the selected film (varnish, dirt, and so on) and remove it at the same time (Figure 7–15). The most important principle of this technique is to allow the solvent to *DISSOLVE* the selected film and *not* attempt to remove it by rubbing or exerting pressure on the Q-tip. If the solvent is not being dissolved easily, a stronger solvent should be selected. During the application of the solvent with the Q-tip, to provide safety for the paint film the action of the solvent should be abruptly stopped after cleaning every few inches. This should be accomplished by soaking a cotton ball in mineral spirits and applying a liberal wash over the area that has been cleaned (Figure 7–16). This diluting wash stops the solvent action from continuing beyond the initial film layer. The wash of

Figure 7–15

Figure 7–16

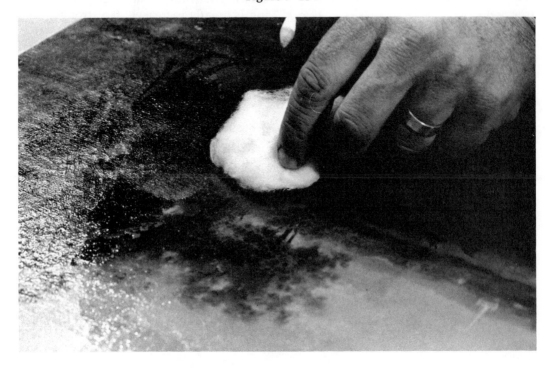

mineral spirits is an added precaution against possible damage to the paint film. It also serves to emphasize the delicacy of the cleaning process.

The Q-tips should be watched carefully during the process of cleaning. Observe the color of the material being removed. The removed material will appear as a grayish black (dirt) color while the surface accretion is being removed and probably a brownish yellow color when the resinous varnish is being removed. If the Q-tip shows any sign of a paint color, the process should be stopped immediately. The Q-tips should be disposed of in a covered glass or metal container as soon as they become dirty.

D.5(b.1) CLEANING SURFACE ACCRETION. To clean the surface accumulation of dirt, smoke films, and so on from our damaged painting, a 10-percent solution of **Igepal**® (a nonionic detergent) should be applied using the Q-tip technique.

STEP 1. In an obscure corner or on the edge of the painting, clean an area the size of a paper clip with the Igepal solution. Allow the area to dry. With a clean Q-tip go back over the *same* area with the Igepal solution; this time the Q-tip should remain clean if the solution is the proper strength. *If* the Q-tip continues to pick up more and more material, the solvent is too strong and the Igepal solution will have to be diluted with distilled water.

STEP 2. Provided the solution is of the proper strength, continue the testing process by spot-cleaning small areas in different locations on the surface of the painting. If all goes well, begin at one corner of the painting and systematically clean one small area after the other.

Note: *Be sure to change the Q-tip as soon as it is dirty and to wash the area with mineral spirits in between Q-tip changes.*

STEP 3. Allow the painting to dry after all the surface accretion has been removed.

D.5(b.2) CLEANING RESINOUS VARNISHES. Cleaning resinous varnishes is a little more difficult than cleaning surface accretion because the age of the varnish greatly affects its solubility, and so it is necessary to have on hand a range of solvents from weak to mildly strong. The following solvents are arranged in an ascending order of strength: Varsol® [Humble Oil Co.], benzine, xylene, toluene, isopropyl alcohol (not rubbing alcohol), and acetone. There are, of course, much stronger solvents available, but in using stronger solvents than those in this list the possibility of damaging the painting is greatly increased. If a stronger solvent than a solution of 30% acetone and 70% toluene is needed to remove the varnish, the painting should definitely be referred to a professional conservator. The weakest solvent available should always be used first. Begin the varnish removal process by starting with Varsol; if that fails to dissolve the varnish, try benzine —and so on, until the proper solvent is found that successfully dissolves the varnish.

The Q-tip technique of applying the solvent, the use of the mineral spirits wash, and pretesting the solvent are the same as for the removal of surface accretion described in Section D.5(b.1).

Note: *As the varnish is being removed,*

the Q-tip will slide and roll with little resistance. When the Q-tip reaches the paint film layer there will be a subtle difference in the feel of the roll: the Q-tip will meet with more resistance or will drag (find a kind of dryness) on the surface. This is the signal that the varnish is removed, and you can move on to an adjacent area.

D.5(c) Cosmetic Treatment

The painting has now been consolidated and cleaned. If possible, it should now be photographed. The painting, although it appears dull, should look cleaner, and the colors should appear more true, although there will still be areas where paint is missing. This section deals with the resurfacing of the painting by **inpainting** and varnishing. *EVERYTHING* performed in this section should be reversible—that is, removable without doing further harm to the original structure.

D.5(c.1) PRIMARY RESURFACING

STEP 1. To isolate all of the existing paint from the subsequent film layers, seal the painting with a spray or brush application of a 10-percent solution of Rohm and Haas's Acryloid B-72. This varnish saturates the color, protecting it and giving it a wet look which will make it easier to match the inpaint colors to the areas surrounding the paint loss.

STEP 2. Allow the varnish to dry thoroughly.

D.5(c.2) INPAINTING. In all areas where
there is paint loss, the ground will have to be replaced with gesso to bring the

Figure 7–17

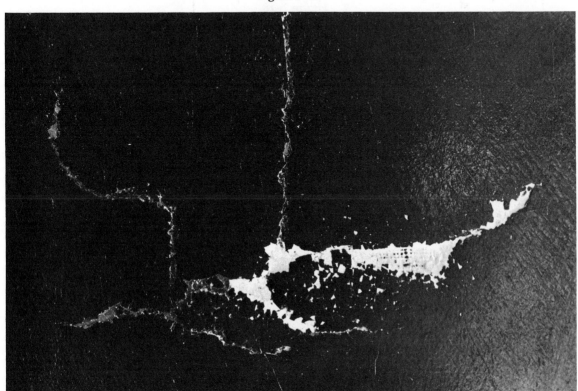

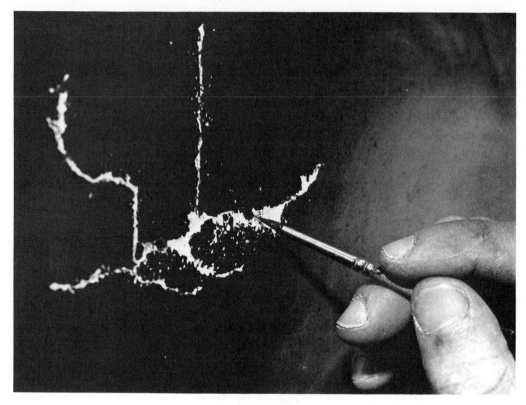

Figure 7–18

area of loss up to the level of the existing paint film. The gesso which will replace the ground is composed of a mixture of whiting or precipated chalk and hot rabbitskin glue.

The technique involved in preparing the rabbitskin glue is in Chapter 3, Section A.1. The formula is 2 ounces of dry rabbitskin glue to 1 quart of water; or, because so little is needed to replace the ground, the recipe may be cut in half—1 ounce glue in 1 pint of water. The whiting is then added to the mixed hot glue in sufficient quantity to make a paste.

STEP 1. Place the painting face up on a clean work table and apply the gesso (hot) to *only* the area of missing ground (Figure 7–17). Any excess that spreads to

an adjacent area should be carefully removed with a Q-tip.

On the damaged painting, the areas of paint loss, as well as the hole and the knife cut (tear), should receive the gesso paste filler (replacement ground). This gesso mixture has the prerequisites for all of the materials used in cosmetic treatment—namely, that they be easily soluble when dry and that they will not discolor with age.

The paint selected for inpainting is Bocour Company's Magna ® color, an acrylic resin **oil-miscible** paint that is soluble in a mild solvent and will not discolor with age. Magna paint should be used even though the artist created the original work in oils. Areas *inpainted*

in oils will eventually change color and appear different than the rest of the painting. The philosophy of inpainting is to fill in *only* the areas of loss and not to paint over any existing paint film.

STEP 2. After the gesso has dried, set the painting up on an easel under good light and fill in the areas where there is paint loss, matching the colors and brush strokes of the original as closely as possible. Use a fine (small) sable brush for inpainting (Figure 7–18).

STEP 3. Allow all inpainting to dry thoroughly.

D.5(c.3) FINAL VARNISH. When the complete inpainting process is finished, all that remains to be done is to apply (spray application) a final varnish of a 10–15-percent solution of Acryloid B-72. Refer to Chapter 6, Section G, for varnishing techniques.

The final varnish film completes the sealing of the painting and will continue to protect and preserve the paint layer.

BIBLIOGRAPHY

BURROUGHS, B. *Vasari's Lives of the Artists.* Simon and Schuster, New York, 1967.

CHAET, B. *Artists At Work.* Webb Books, Cambridge, Mass., 1960.

DOERNER, M. *The Materials of the Artist and Their Use in Painting, with Notes on the Techniques of the Old Masters.* Harcourt, Brace, New York, 1949.

EASTLAKE, C. L. *Methods and Materials of Painting of the Great Schools and Masters.* Dover Publishing, 1960 (reprint).

GETTENS, R. M., and G. STOUT. *Painting Materials: A Short Encyclopedia.* Dover Publishing, New York, 1966.

HARLEY, R. D. *Artists' Pigments, c. 1600–1835: A Study in English Documentary Sources.* American Elsevier, New York, 1970.

HERRINGHAM, J. *The Book of the Art of Cennino Cennini: A Contemporary Practical Treatise on Quattrocentro Painting.* George Allen and Unwin, London, 1922.

KECK, C. K. *Safeguarding Your Collection in Travel.* American Association for State and Local History, Nashville, Tenn. 1970.

LAURIE, A. P. *The Painter's Method and Materials.* Dover Publishing, New York, 1967.

MAYER, R. *The Artist's Handbook of Materials and Techniques.* Viking, New York, new ed., 1970.

MAYER, R. *A Dictionary of Art Terms and Techniques.* T. Browell Co., New York, 1969.

MERRIFIELD, M. P. *Original Treatises on the Arts of Painting.* Dover Publications, New York, vols. 1 and 2, 1967.

ORGAN, R. M. *Design for the Scientific Conservation of Antiquities.* Smithsonian Institution Press, Washington, D. C., 1968.

PEACHAM, H. *Peacham's Compleat Gentleman* [1634] Oxford, London (reprint) 1906.

PLENDERLEITH, H. J. *The Conservation of Antiquities and Works of Art.* Oxford University Press, London, 1972.

POPE, M. *Introducing Oil Painting.* Batsford/Van Nostrand Reinhold, New York, 1969.

REED, K. *The Painter's Guide to Studio Methods and Materials.* Doubleday, Garden City, New York, 1972.

RUHEMANN, H. *The Cleaning of Paintings: Problems and Potentialities.* Praeger, New York, 1968.

TAUBES, F. *Painting Materials and Techniques.* Gramercy Publishing, New York, 1964.

REFERENCES

MANUFACTURERS OF ARTISTS' SUPPLIES

In order to locate supplies in your area, write to the manufacturer for a list of their distributors.

BARECO OIL CO.
Box 390
Kilgore, Texas 75662

BOCOUR PIGMENTS
1 Bridge Street
Garnerville, N. Y. 10923

BORDENS, INC.
Dept. CP
New York, N. Y. 10017

E. I. DUPONT DE NEMOURS & CO.
1007 Market Street
Wilmington, Del. 19898

EASTMAN KODAK CO.
343 State Street
Rochester, N. Y. 14650

FEZANDIE & SPERRLE, INC.
103 Lafayette Street
New York, N. Y. 10013

FISHER SCIENTIFIC CO.
709 Forbes Street
Pittsburgh, Pa. 15219

FORMICA CORPORATION
120 East 4th Street
Cincinnati, O. 45202

GAF CORPORATION
P. O. Box 700
Linden, N. J. 07036

GLAS-KRAFT, INC.
Railroad Street
Slatersuill, R. I. 02876

M. GRUMBACHER, INC.
460 West 34th Street
New York, N. Y. 10001

JAMES HOWARD COMPANY
P. O. Box 288
Compton, Ill. 61318

KIMBERLY & CLARK
2001 Marathon Avenue
Neenah, Wis. 54956

KRYLON, INC.
Ford and Washington Streets
Norristown, Pa. 19401

MASONITE CORPORATION
29 North Wacker Drive
Chicago, Ill. 60606

MASTERSON ENTERPRISES, INC.
4350 East Camelback—150B
Phoenix, Ariz. 85018

MONSANTO COMPANY
800 N. Lindberg Blvd.
St. Louis, Mo. 63166

PENNSYLVANIA CHEMICAL CORP.
800 Estes Avenue
Elk Grove Village, Ill. 60007

PERMANENT PIGMENTS, INC.
2700 Highland Avenue
Cincinnati, O. 45212

ROHM & HAAS
Independence Mall West
Philadelphia, Pa. 19105

SHIVA ARTISTS' COLORS
10th and Munroe Street
Paducah, Kentucky 42001

TALAS CO.
104 Fifth Avenue
New York, N. Y. 10011

UTRECHT LINENS, INC.
33 Thirty-fifth Ave.
Brooklyn, N. Y. 11232

WEBER COMPANY
Wayne and Windrin Ave.
Philadelphia, Pa. 19144

WINSOR & NEWTON, INC.
555 Winsor Drive
Secaucus, N. J. 07094

GLOSSARY

Abraded. A surface that has been worn off or otherwise damaged by friction or scraping.

Acrylic. A type of synethetic resin formed by the polymerization of acrylic acid esters.

Alkali. The hydroxides of the alkali metals (lithium, sodium, potassium, rubidium, and cesium), also ammonium hydroxide, which neutralize acids to form salts.

Alla Prima. Italian term for direct painting, or the process of achieving final effects with one application of paint.

Aperture. The camera lens opening that is controlled by a diaphragm.

ASA. American Standards Association's numerical system for indicating the film emulsion's speed or sensitivity to light.

Aqueous. Containing water or soluble in water; generally used in reference to paints and glues.

Barndoors. Shutters or flaps which are attached to the front of the reflector of a photo light in order to control the shape of the light.

Barreling. The appearance of a barrel-shaped distortion (bowing out of the top and sides) of a rectangular figure due to spherical aberration of the lens.

Bloom. A cloudy, blue-white surface effect on a varnish film.

Calcine. To burn or roast at a high temperature.

Canvas. A general term for a closely woven fabric of linen or cotton.

Canvas Board. A stiff cardboard with one side covered with a fabric prepared for painting.

Carborundum. An artifical abrasive, silicon carbide, Si C.

Catalyst. A substance that causes or accelerates a chemical change or reaction.

Cellulose. An inert, carbohydrate substance, the chief ingredient of the cell walls of plants. A principal part of wood, hemp, cotton, paper, etc.

Chipboard. An inexpensive cardboard made from recycled paper.

Collage. Affixing cloth, paper, string, and so on, to a canvas as part of the general aesthetic requirement.

Colophony. Another name for rosin—the residue of the balsam of pine trees after the spirits of turpentine have been distilled.

Color Control Patches. Trademark of Eastman Kodak Company. A card on which is printed eight standard graphic ink colors. The card provides a standard reference for the mixing of printing inks.

Color-tone Viewer. A glass-viewing filter which allows the human eye to see the subject as it will reproduce on color film.

Conservation. The act of preserving works of art or historic objects.

Conservator. A professional practitioner in the art and science of conserving works of art and historic objects.

Consolidate. To reinforce, restructure, or strengthen a work of art to prevent further loss or damage.

Cosmetic Treatment. Restoration techniques that aid in the aesthetic perception of a work of art.

Cotton. The soft, white substance attached to the seeds of plants of the malvaceous genus Gossypium.

Countersink. To create a cone-shaped opening with a countersink bit to admit the head of a wood screw, so that the screw head will be flush with the surface of the wood.

Craquelure. French term widely used in the field of art conservation to describe cracks in the varnish or paint film of a painting.

Cupped. Conservation term used to describe the condition of paint film that has curled or lifted edges forming a dishlike shape.

Diluent. A liquid that thins or dilutes another solution.

Drier. A compound that has a catalytic action upon oil paint, resulting in an accelerated drying time.

Drying Oil. An oil that dries forming a tough, flexible film.

Dye. A liquid color pigment in solution.

Emulsify. To make into an emulsion—the suspension of one immiscible liquid in another.

Encaustic. Pigment in a wax medium. Used in painting by applying the wax colors hot, followed by fusing the layers with applied heat.

Ester. A compound formed from a reaction between an alcohol and an acid by the elimination of water.

Excelsior. Fine wood shavings used for packing.

Exposure Meter. An electrical or optical device that measures the amount of light reflected from or illuminating a photographic subject.

Extender. Any inert material that extends or increases the quantity or bulk of oil paint.

Facing. A process and a term used in the field of conservation to describe the application of a layer of tissue and adhesive to the front of a painting to immobilize the paint layer.

Feathering. A final brush stroke made by lightly drawing the brush in one direction across the painting and ending in a lifting motion.

Ferrule. The band or tube that holds the bristles or hairs of a brush together and attaches them to the handle.

Filter. A colored glass or gelatin used in photography to affect the color rendition of film or diminish the intensity of light.

Fissure. A term used in conservation to denote a crack or split in the paint film.

F-Stop. A numerical unit of measure used in photography to denote the aperture setting of a lens.

Flag. The split end of a single hog bristle.

Flaking. The process by which paint separates from its support.

Flash Point. The lowest temperature at which the vapors of a liquid can be ignited.

Formaldehyde. The gas CH_2O used in an aqueous solution.

Fome Cor. Trademark of the Monsanto Company. A foamed plastic laminated between two sheets of heavy white paper.

Formica. Trademark of the Formica Corporation. A thermosetting plastic laminated into sheets.

Frond. The leaf of a palm tree.

Fugitive. A paint that either changes color, fades, or bleeds (leaches) into neighboring or overlayed paints, affecting their color.

Gelatin. A refined glue made from protein material obtained by boiling the material (animal bones, ligaments, etc.) in water.

Gesso. Whiting or chalk mixed with a glue solution or an acrylic resin.

Glassine Paper. A glazed, transparent or translucent paper.

Glue-Gesso. Whiting or chalk mixed with an aqueous glue solution.

Gray Card. Trademark of Eastman Kodak Company. A card printed with a neutral (18% reflectance) gray color.

Ground. The first layer of paint film which provides the proper surface for the application of subsequent layers of paint films.

Gum. A hardened plant or tree exudation or sap soluble in water.

Igepal. Trademark of the GAF Corporation. A nonionic detergent which is a ethoxylated alkyl phenol.

Impasto. Thick or heavy application of paint.

Inert. A material without active properties.

Inpainting. The process in conservation whereby the conservator paints in the missing areas of paint on a painting.

Kelvin Degrees. A unit of temperature used to designate the color temperature of a light source.

Keys. Wood or plastic triangular-shaped wedges that fit into the slotted inside corners of a stretcher frame. When driven into the slotted corners, they spread the the corners apart, increasing the tension on the stretched canvas.

Kimpak. Trademark of Kimberly and Clark. A paper padding composed of several layers of crepe paper.

Lacquer. A natural or cellulose compound dissolved in a volatile solvent. Can be clear or pigmented, and dries with a high smooth gloss.

Lake. A liquid dye that is precipitated upon an inert material, so that it may be ground with oil to make paint.

Linen. A cloth or fabric woven from the fibers of the flax plant.

Lining. A process in conservation that laminates a new fabric support to the old fabric support of a painting.

Linseed Oil. A natural vegetable drying oil that is expressed from the seed of the flax plant.

Masonite. Trademark of the Masonite Corporation. A sheet panel made by compressing wood fibers under pressure.

Medium. The binder or vehicle in which the pigment is dispersed to make paint.

Mixed Media. Using more than one type of material on the same surface to create a painting.

Modular. Constructed with or based on a standardized unit (module) for interchangeability.

Mordant. An oil or varnish used as an adhesive for the application of metal leaf (gold, etc.) to a surface.

Mulberry Tissue. A very strong, handmade Oriental paper (tissue) composed of 50% Kozo vegetable fiber combined with Mulberry bark.

Mull. To grind, pulverize, or mix thoroughly.

Mylar. Trademark of E. I. Dupont. A polyester sheeting.

Oil Glazes. Thin film layers of transparent paint applied one over the other to create unique optical effects.

Oil-Miscible. The ability to mix with oil.

Oil Varnish. A resin cooked and dissolved in a drying oil.

Paint. Pigment ground in a vehicle or medium.

Painting Knife. A tempered steel blade in various trowel-like shapes and sizes with a bent tang (shank) and wood handle. Used to apply paint to a surface.

Palette. (1) A nonabsorbent surface on which to mix paint. (2) The range or selection of colors a given artist or school of art prefers.

Photo Lamp. An incandescent lamp with a high wattage rating and specific color temperature. Another name for the common tungsten lamp.

Pigment. A finely ground (powdered) coloring substance or matter.

Plumb Bob. A weight at the end of a string or cord that when freely suspended will be a true perpendicular or vertical line.

Plywood. Various thin sheets of wood that have been cross grain laminated into a single sheet.

Polarize. To cause light to vibrate in a single plane by passing it through a filter.

Polymer. A compound of high molecular weight formed by uniting a number of identical molecules into larger molecules.

Polymerize. To undergo the process of polymerization, in which the monomer is combined with like molecules forming a polymer of new molecular weight, structure, and chemical properties.

Polyvinyl Acetate. A vinyl resin that is polymerized by adding peroxides and heat.

Precipitate. To separate out from a solution and deposit a substance in solid form by adding a precipitating agent or reagent to the solution.

Primed. A surface that has been prepared for painting by the application of a ground.

Quartz-Iodine Lamp. An alternate name for a tungsten-halogen lamp. When the chemical elements related to iodine (halogens) are added to the normal gas in a lamp, the inner bulb wall remains clean during the burning of the filament. This process maintains a steady color temperature for the life of the lamp.

Quill. The root base or hard tubelike part of a large feather.

Rabbitskin Glue. A glue made from boiling the skins of rabbits.

Register Marks. A symbol, usually cross lines in a circle printed on cardboard. In a color photograph, they provide a standardized reference for the accurate alignment of color separations.

Resin. An organic substance obtained from certain plants and trees as exudations.

Restoration. A phase in the process of conservation when the missing parts or areas are filled in or replaced.

Rim Resin. A resin that has been liquified by heating.

Rosin. Another name for colophony.

Saponify. To convert a fat or oil into a soap by boiling with an alkali.

Scumble. A thin film of a light opaque color applied over a darker color.

Shade. A darker degree of a color.

Shank. The round steel shaft from which the painting knife blade is formed and to which the handle is joined, also called the tang.

Shutter Speed. The amount of time the shutter remains open and the film is exposed to light. Usually measured in fractions of a second and controlled by an adjustable setting on the camera.

Siccative. Another name for drier.

Silica. Silicon dioxide, SiO_2 appearing as quartz, sand, or flint.

Size. Aqueous (water soluble) glues or gelatins used in the preparation of a support for oil painting.

Solution. A gas, liquid, or solid dispersed homogeneously in a gas, liquid, or solid without chemical change.

Solvent. A material or substance that dissolves another material or substance.

Stabilizer. A material that is used in the manufacture of oil paint that will discour-

age the separation of the pigment from the oil.

Standard Gray Scale. Trademark of the Eastman Kodak Company. A standardized scale progressing from white to black in ten increments. Used as a reference in black and white photography.

Strainer. A wood frame for the support of canvas that does not have expandable corners.

Strap. A flat piece of metal used to hold a painting in its frame. Also known as a mending plate.

Stretcher. A wood frame for the support of a canvas that has expandable corners.

Support. Any material or combination of materials (canvas, wood, paper, etc.) to which the paint is actually applied.

Tack-Over Edge. The excess canvas that folds around the stretcher or strainer through which the tacks or staples are driven.

Tempera. Pigment ground in water and mixed with a water-miscible emulsion; usually the yolks of eggs.

Tint. A lighter degree of a color.

Toner. A concentrated lake containing very little inert material.

Tungsten Lamp. An incandescent lamp with a tungsten filament that yields a specific color temperature.

Varnish. A resin dissolved in a volatile solvent.

Viscosity. The internal property of a fluid which influences it to resist flow or effects its rate of flow.

Wedges. Another name for keys.

Wratten. A system of identifying and coding color filters used in photography. Developed by Frederick Charles Luther Wratten in 1906. The rights and use of the name are now owned by the Eastman Kodak Company.

INDEX